ONE SMALL FARM

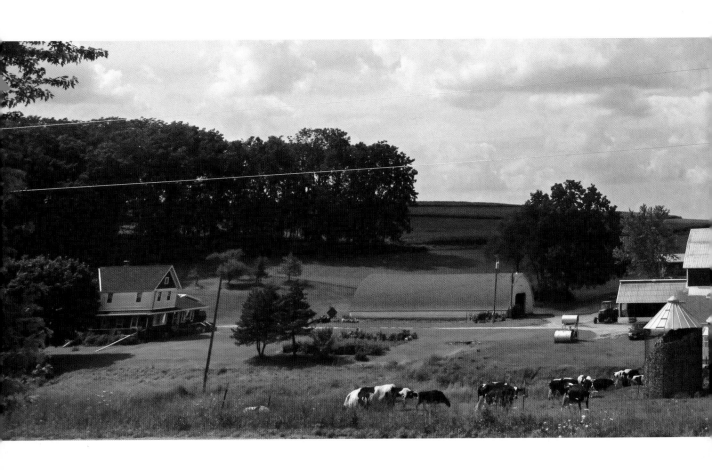

ONE SMALL FARM

PHOTOGRAPHS OF A WISCONSIN WAY OF LIFE

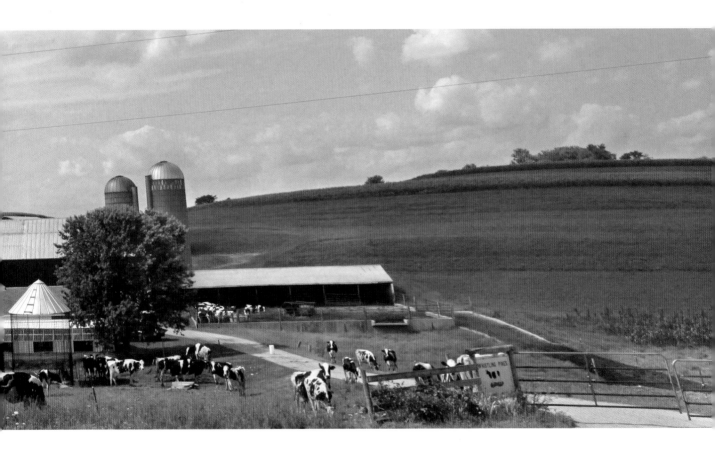

CRAIG SCHREINER

WISCONSIN HISTORICAL SOCIETY PRESS

One Small Farm: Photographs of a Wisconsin Way of Life
was made possible, in part, by a generous grant from
The Edwin E. & Janet L. Bryant Foundation,
with additional funding from
Dairyland Power Cooperative and The D.C. Everest Fellowship Fund.

Published by the Wisconsin Historical Society Press
Publishers since 1855
© 2013 by *Wisconsin State Journal*

wisconsinhistory.org

Printed in the United States of America
Designed by Percolator Graphic Design
17 16 15 14 13 1 2 3 4 5

Library of Congress Cataloging-in-Publication Data
Schreiner, Craig.
 One small farm : photographs of a Wisconsin way of life / Craig Schreiner.
 pages cm
 ISBN 978-0-87020-617-7 (alk. paper)
 1. Farm life—Wisconsin—Pictorial works. 2. Lamberty family—Pictorial works. I. Title.
 S521.5.W6S37 2013
 636.009775—dc23

 2013011735

To the Lamberty family

ACKNOWLEDGMENTS

Kate Thompson, senior editor at the Wisconsin Historical Society Press, is responsible for these photographs being presented in book form. Her persistence after seeing some of the pictures appear in a newspaper article has given them a longer life and made it possible to present them as a complete work. John Smalley, editor of the *Wisconsin State Journal,* and Steve Apps, the *State Journal*'s chief photographer and my friend and colleague of many years, gave their wholehearted support and help to the project. My wife, Lisa, and I have been together always, and I would be so much less without her. And of course, to Marie, Jim, Gordy, and Vicky Lamberty: I came looking for a documentary project, and I found friendship.

Many of my earliest memories are of my father when he was a young farmer. I remember being six or so, playing in a field of dark sod he had just turned with a plow. The damp earth felt cool and it smelled good. I relive that moment every spring when I start our vegetable garden. Many years later, my wife and I visited Old North Bridge near Concord, Massachusetts, site of the first battle of the Revolutionary War. Near the bridge is a statue by the great sculptor Daniel Chester French of a minuteman, musket in hand, striding from his plow. I was stunned by the human figure in the sculpture. It looked just like my dad, the young farmer.

Most of what I know about farmers and farming I know because of you, Dad.

"The small family farm is one of the last places—they are getting rarer every day—where men and women (and girls and boys, too) can answer that call to be an artist, to learn to give love to the work of their hands. It is one of the last places where the maker—and some farmers still do talk about 'making the crops'—is responsible, from start to finish, for the thing made."

—Wendell Berry

INTRODUCTION

As a photojournalist, I'm a little embarrassed to admit that sometimes I just drive around and look for pictures. And that is how this project began.

I was assigned to find a picture for the local page of the next day's newspaper. None of the stories planned for that day were visual stories, and my mission was to come up with a picture that would stand on its own and carry the page. In the news business, we call these pictures "wild art" or stand-alone features. If the picture isn't great, it's nothing more than filler for the page and a waste of time for readers. Finding these compelling pictures can take hours. Some photojournalists are artists at creating stand-alone features. Others hate the investment of time they require. On any given day, you will find me somewhere in between.

Almost without fail, when I draw these assignments I go to the country. I try the small towns and the back roads. I may feel like I've seen it all in Madison—or most of it, anyway—but I haven't yet seen it all in Ashton or Dane or Lodi or Pine Bluff. And that is how I happened to be making a right turn onto Valley Spring Road on a sunny afternoon in August of 2009. It was nearly four—which I would learn the following year was milking time.

And there it was, in a hillside field. What I saw that day was something familiar to me from my youth. It was a parade of sorts—a long parade of machinery. At the front was a tractor pulling a hay baler, which was launching oblong bales through the air and into a wagon being pulled behind. I parked at the edge of the hayfield. I wouldn't have much time. The baler was advancing steadily on the few remaining windrows of hay. The late afternoon light transformed the scene to golden, rosy hues, revealing every detail.

I may have waved to the man driving the tractor. I don't remember. Either way, he went on doing his work as I did mine. When he had finished baling up the last of the rows, we talked. He wore a dusty cap, a ragged plaid shirt. He had clear eyes and an easy, wide smile. This was his and his brother's land, he told me. The farm was over the hill, and they had been farming it since they were mere boys working with their parents. Now they lived there with their mother.

That got my attention. The man looked to be around sixty years old. Two brothers and their mother, working a small dairy farm together just as they had been doing every day, all of their lives. I heard myself ask on the spot if I could come to their farm and spend some time photographing them. "Come

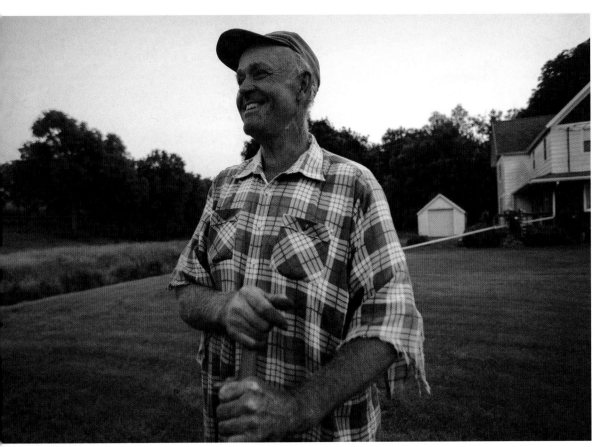

Jim Lamberty

any time," he said with that wide smile. And he went home to milk cows with his brother.

That was my introduction to Jim Lamberty. When I showed up at the farm in early February 2010, I met Jim's brother, Gordy, and their mother, Marie. On a later trip I met Gordy's fiancée, Vicky.

I visited the Lamberty farm on and off for more than two years. Most of my assignments at the paper were conceived by reporters and editors, but this was *my* project. These were my pictures. And, having grown up on a farm and in small towns, I felt these were my people. The project became a constant in my life through tumultuous stories like the 2011 labor protests in Madison and through anxious times of staff cutbacks at the newspaper. And it became a source of inspiration that made all of my photojournalism better.

People's lives are written on the fields of old farms.

The rows of the fields are like lines on a page, blank and white in winter, filled with each year's story of happiness, disappointment, drought, rain, sun, scarcity, plenty. The chapters accumulate, and people enter and leave the narrative. Only the farm goes on.

Jim and Gordy Lamberty have farmed together every day of their adult lives on 180 acres their family calls Whistling Pines Farm, near the village of Pine Bluff, a tiny crossroads in western Dane County between Mount Horeb and Cross Plains. Less than fifteen minutes to the east is the city of Madison, the state capital.

The brothers' lives follow the routine of twice-daily milking and the rhythm of the seasons. They milk forty Holstein cows and call them by name. "Thelma" stands next to "Louise."

In the milking barn, few words pass between the two men as they move among the cows, feeding, cleaning, and connecting each one in turn to the milk pipeline. Words are unnecessary when you have worked together for decades. A radio plays country music and announces the weather report. The cows shift in their stalls, munching the hay and feed spread in front of them. The milking machine makes a soothing "tick, tick, tick" as it draws the milk

from the cows into the pipeline and then into the big refrigerated bulk tank in the milk house attached to the barn. Every other day around 8:30 in the morning, Rick Edwards backs up his big truck to the barn and collects the milk from the tank. The Lamberty farm is just one stop on his route picking up milk from dairy farms and delivering it to Stockton Cheese, Inc., in Stockton, Illinois, where it is used to make natural aged Swiss cheese.

Milk in the morning. Milk at night. Feed cows and calves. Plant crops. Grind feed. Chop and bale hay. Cut wood. Clean the barn. Spread manure on the fields. Plow snow and split wood in winter. In the spring, gather the rocks that the frost has pushed to the surface of thawing fields. Cultivate corn. Pick

The brothers prepare for evening milking.

corn. Harvest oats and barley. Help calves be born. Milk in the morning and milk at night.

It is a routine that has gone on here for decades. Most of the things that are important to my friends in the city and on Facebook, things that are worried over and debated, written about, satirized and analyzed, are not on the Lambertys' radar. Here there is harmony and sweetness and things that need doing over and over every day. In the summer of 2012, I asked Gordy if he had seen any of the Republican National Convention on television that week. No, he replied—he had given up following politics because it had become too bitter. It occurred to me that if our politicians have lost the attention of thoughtful, earnest people like this, we are in big trouble.

There are two things conspicuously absent from the Lamberty farm. One of them is leisure time. The days blend together in a pattern of physical work that begins before sunrise and ends after dark. Meals start with prayer and are taken between work. Breakfast is eaten when the morning milking is over and before the day's fieldwork begins. Dinner is eaten when the fieldwork ends and before the evening milking begins. The farm, the animals and crops, are attended to and nurtured each day through the work. The farm provides food. And a way of life. On the occasions that I have walked into the empty barn when none of the Lambertys were around, it felt eerie and strange. Cows become accustomed to their people, and they lower their heads and look warily at strangers. This place has become accustomed to the Lambertys' presence and care.

The other thing noticeably missing here is this: in all my visits to the farm over more than two years, I never heard a harsh word, never a word expressed in mean-spiritedness or anger.

Gordy explained:

For Mother and Dad, you worked together. You just worked together until you were done. A lot of operations don't succeed, but some do. And if you like what you're doing, you just do it. We both milk. We don't stick one with the milking and not the other. We're both there. When it's chore time, we both quit in the field and come in [for milking].

Jim Lamberty was three years old when his parents, Marie and Harley Lamberty, moved to the farm in 1951; Gordy would be born to the farm. Jim has no memory of moving day, but he can recount the history passed along by his parents:

The day Ma and Dad moved here from the Reisdorf farm, which was the little farm across from what is now the Hilltop Restaurant in Pine Bluff, they drove the [sixteen] cows down the road. They didn't haul them. Harold Laufenberg— he is deceased now, but he was a really big man, I mean well-built and strong— he carried a calf all the way here on his shoulders. It was too young to walk all that way, so he carried him. I remember Dad saying that Harold carried that calf all the way from north of Pine Bluff. By road, that's probably three miles. That's when neighbors helped neighbors. Everyone had twenty-five to thirty cows in those days. They were [considered] big herds. Everybody had a few pigs. Everybody had a few chickens. Everybody had everything.

Jim's face lights up when he surveys the surroundings today, his pride showing in kind of a glow when his gaze settles on the fields of crops, the tidy buildings, and even three of their farm tractors—"Dad's tractors," which their father bought and which they still use for many jobs: a 1948 John Deere B; a 1946 McCormick Farmall B; and a 1954 McCormick Farmall M-TA, a big workhorse of a tractor in its day.

When Jim and Gordy graduated from high school, their parents paid them a percentage of the family's milk check for their work on the farm. They started small, earning about 5 percent of the check, working their way up to 10 percent. Eventually they also had to pay a percentage of the expenses. Marie worked to support the family too and once raised about four hundred chickens, selling the eggs in Madison. When she discontinued her egg route, she took a part-time job off of the farm as a cook.

At age ninety, Marie still lives in the farmhouse with Jim, preparing meals and helping with the milking. She goes to the milk house and fills a jar with rich, raw milk to serve with meals. Marie's eyesight is failing, but she helps with chores, like scraping away the uneaten bits of feed from in front of the cows in their stanchions. When the milking is finished and the cows can be

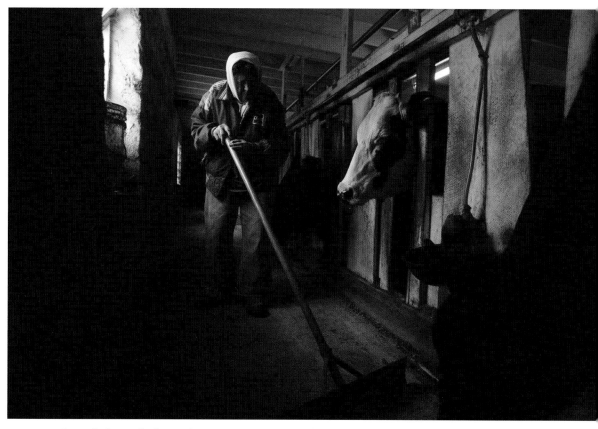

Marie Lamberty helps with chores during milking time.

released from the barn, the petite Marie shoos the behemoths out of their stalls and helps her sons clean up after them.

"Everybody scolds me for going to the barn," she told me, smiling over the concern of just about everyone for her safety. "I tell them, well, I can fall in the house too. I think about what day it is and what's going on, and you got to keep a-moving. When you get up and go out there, you are glad you did it."

Harley Lamberty died in September 1989. His grave is marked by a simple gray monument near the top of a hill above St. Mary of Pine Bluff Catholic Church. Marie's name and birth date are on the monument as well, for the time when the two of them will be together again. A few steps away is the grave of Harold Laufenberg, the strong neighbor who carried the calf on his

shoulders all the way to the Lambertys' new farm. From that little hilltop cemetery, farm fields stretch out as far as the eye can see.

By the time of their father's death, Jim and Gordy Lamberty were firmly established on the farm. What had always worked for the farm, the brothers did not change. Drivers who pass the farm on a sunny day in June might be fortunate enough to see a sight common sixty years ago: a 1948 John Deere B tractor with a two-row cultivator mounted on it, putt-putting along the hillside with Jim or Gordy at the helm. The tines break up the soil between the young corn plants and dislodge the weeds.

"It's just like growing your garden," Gordy explained. "You go out there and you hoe it and give it air and things grow. But thousand-acre farms can't do that. So we're small and we're old fashioned, but it does have its advantages."

Nostalgia is not why the brothers still farm with small machinery or why they have kept the size of their farm at 180 acres. This is an efficient operation, with a history of success. The machinery suits the farm, and the size of the farm suits the Lambertys. Most of the crops go to feed the dairy herd for the year. The two silos next to the barn are filled with chopped corn and chopped hay. In the fields surrounding the farmyard, contoured strips of green corn, soybeans, and hay are interspersed with tan and gold barley and oats. The Lambertys carefully rotate crops to keep nutrients in the soil. This will always be one small farm. As Gordy said,

The rewards to me are the beauty of the land . . . and the animals. New calves being born—after they just drop on the ground and they're kicking around trying to get up. That's what I like. It's hard work. It's long hours. Little pay. But you're your own boss. There's some freedom in that, some satisfaction of being your own boss and doing what you want to. If you want your farm and your buildings to fall apart, it's your own problem. If you want to take pride in what you do, then that's what you do. You kind of determine your own destiny. I don't know if I could sit in an office, look at a computer screen like Vicky does. You make all the decisions and you do what you want to do today, tomorrow, next year. The downside is . . . you gotta do all the work. Cows gotta be milked night and morning, seven days a week.

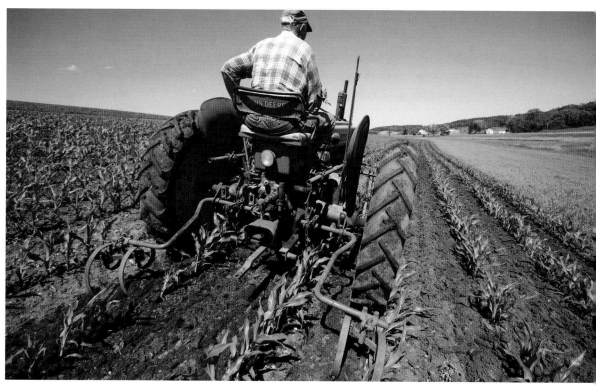

Jim Lamberty cultivates corn.

Jim agreed. "Small farms . . . only way they can survive is, you dasn't have a debt load. No debt load is the secret right now. I mean, it's long hours, seven days a week, 365 days a year. But I guess I've enjoyed it."

❖

Everyone must have thought Gordy and Jim were confirmed bachelors. But another chapter in the story of the farm began when a friend of Gordy's from church nominated Vicky Skilondz for one of the volunteer church councils. Vicky wrote a biography of herself for the church bulletin, and Gordy read it there. He kept it for six months, and then he finally called Vicky to ask for a date. They met for lunch on a Saturday in October 2008.

Born near Chicago in Brookfield, Illinois, Vicky was eleven when her family moved to Lodi, in southern Wisconsin. They weren't farmers, but they lived on the outskirts of town. She enjoyed the open air and went on long walks in the fields, sometimes taking along a sack lunch. She found Gordy to be as refreshing as those walks.

"We talked about everything," she told me. "He was super honest, really refreshing. He's generous, loving, honest, all those good things rolled into one. And he's not bad looking, either."

Vicky's sense of humor and work ethic have helped her fit into the Lamberty family, but trying to have a serious relationship with a farmer wasn't easy. When other couples went on dinner dates or weekend adventures, Gordy would be working. And he and Jim had never taken a vacation. Ever. Vicky said,

> When we first started dating, I realized he couldn't get off the farm much, so I would ride with him and spend time with him so that we could get to know each other. He was so busy, I figured if I didn't come, you know, we wouldn't see each other much. So I started doing the books too, because it was taking him a little while and we couldn't go out as much. The more we talked, the more we get to know each other. It was a good time. We just carried it on. We haven't stopped that yet.

In April 2010, Gordy and Vicky were married. Jim was Gordy's best man. The day of the wedding was the first time anyone could remember that both of the brothers were absent from milking at the same time. Friends milked their cows for them on the night of the celebration.

For the first time in his life, Gordy moved off the farm. The couple rented a duplex in Mount Horeb, about fifteen minutes from the farm, and now Gordy commutes to the farm. Vicky works at West Middleton Lutheran Church and also uses her business skills to do the bookkeeping for the farm. She often helps the brothers with the monthly milk butterfat testing. She is still learning about farming:

> I had no idea what farming was. It's extremely messy. I was not used to that. Basically there's "stuff" [manure] everywhere. [Gordy] had to teach me

everything. He has the patience of a saint. Our agreement was that I would teach him spreadsheets, and he would teach me about cows. There's limits for me. There's things I don't do. Anything involving bodily fluids, I'm out of the barn. Anything involving a very long glove I don't participate in, either. I have my limits.

In the soft, warm light of an early evening in June, Vicky and Gordy can be found picking strawberries in the garden plot they share with Marie and Jim on the farm. An amiable farm cat cruises through the tall stems and brushes and bumps up against Gordy, hoping for a chin scratch. Tiny, sweet straw-berries cover the bottom of Vicky's white pail. She tells me,

It's these little places that have a uniqueness about them and still have a con-nection with the land that are important. Should everything be technically advanced? I don't think so. People have a right to live a simple life, a hard life, if they want to. [Gordy and Jim] love the land. They really do. I know that

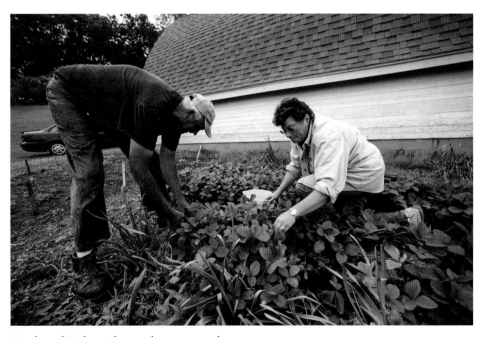

Gordy and Vicky pick strawberries together.

for a fact. They do things the hard way. Change would mean more chemicals, fertilizers. They choose not to do that. Smaller farms can still make some of those choices. I think they're relevant. All of this is relevant.

Marriage has made Gordy reflect more on the meaning of the farm. "One thing I took for granted was that in the morning and at night when we go home from the farm or come to the farm, either way, the sun rises and the sun sets. I just took it for granted.

"We just sometimes sit and look at it now."

The author Norman Maclean talked about toughness and beauty. He was asked in an interview to describe growing up and working as a teenager in logging camps and for the US Forest Service near Missoula, Montana, during World War I, when many local men were away fighting and boys like Maclean took their places at jobs on the home front. "It was beautiful and very tough," Maclean said. "It was a tough kind of beauty."

I thought of those words whenever I visited the Lamberty farm. A tough kind of beauty.

Everything the brothers do seems to involve pushing, pulling, prying, lifting, carrying, climbing, shoveling, pounding, bending, and stooping. And a lot of that is done in cold or heat, rain or snow. They are lean, sculpted from the elements and from years of manual labor. In youth that kind of farming makes a person powerful. As the years pass, a lifetime of accumulated wear shows on the human body. "Jimmy's got bad knees and hips, so I do all the climbing," Gordy said. "That's just the way that it is." But then there is the part about the beauty and about what keeps people on the land.

Around the kitchen table on a spring afternoon in 2011, the brothers reflected on why they chose farm life. Gordy said,

I like to see the change of the seasons. I couldn't live with winter all the time, I couldn't live with springtime all the time. I gotta have those changes.

You see the fruits of your work, you know. You see the stuff planted. You see it grow. You nurture it. You harvest it. And then you rest [*he laughs*].

Jim said he prefers spring, when everything starts greening up.

I don't like winter. I don't like real cold weather. I can take heat, but I can't take cold. Spring is probably my favorite time of year. Mother Nature's come and [everything is] waking up. I like to see things getting green. . . . I like working out in the open air. We have one tractor that has a cab on it, and that's in the wintertime. And in the summertime, I don't even like a cab because I'm allergic to air conditioning. I can't stand air conditioning. I like the wind blowing at my face.

Around the same time, Jim told me, "I'm kinda thinking that down the road, within three to four years, that will be it. I'm gonna be sixty-three in September." Over the next year, both men were challenged by nagging problems in the legs, knees, feet, and hips. Selling the dairy herd kept coming up in family discussions. Selling the cows would eliminate a huge amount of work every day. Still, they were hanging in there, as they would frequently say. It's a tough kind of beauty.

ONE SMALL FARM

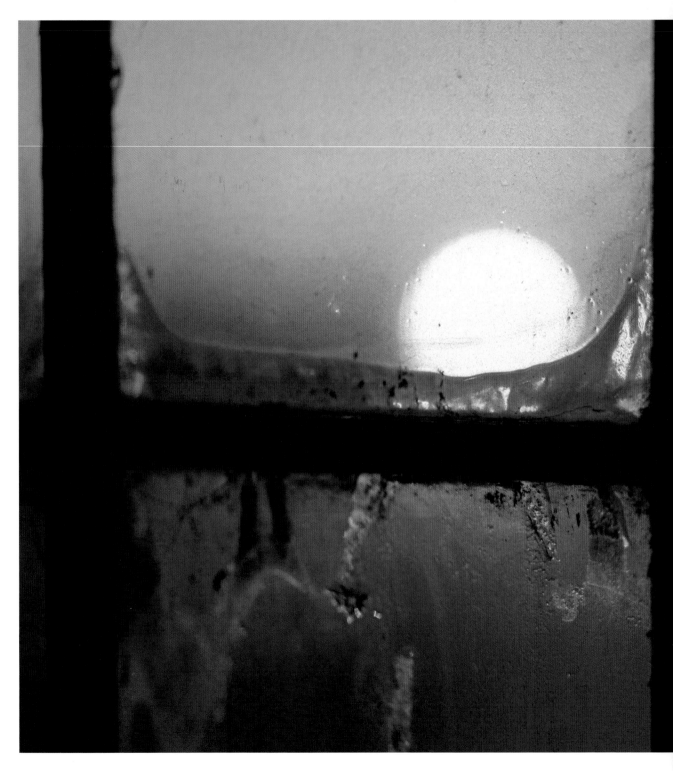

The morning sun illuminates an ice-coated
window in the Lamberty barn.

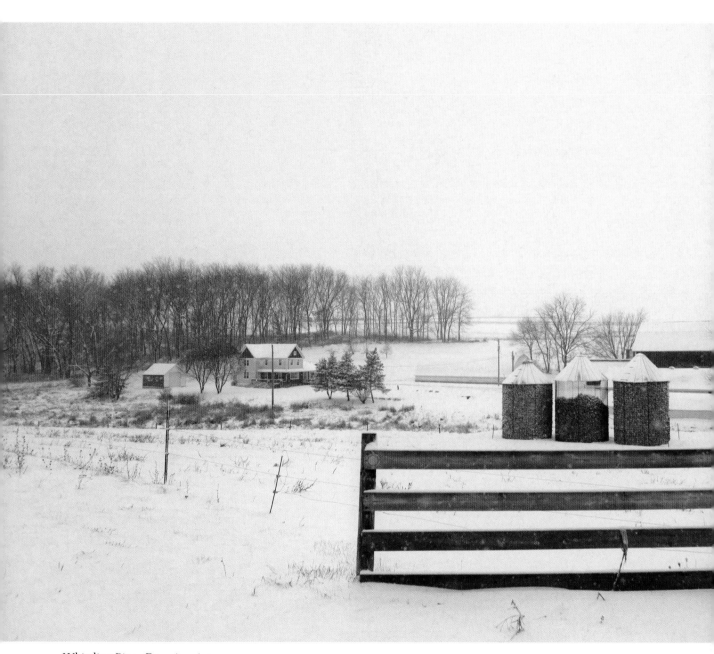

Whistling Pines Farm in winter

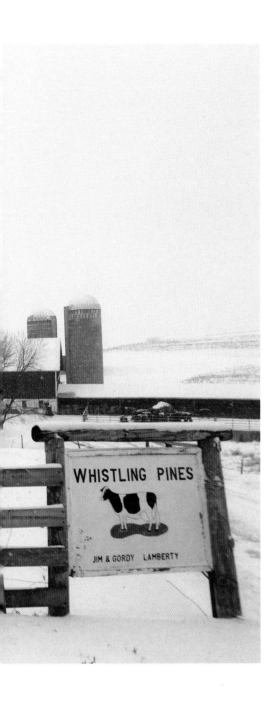

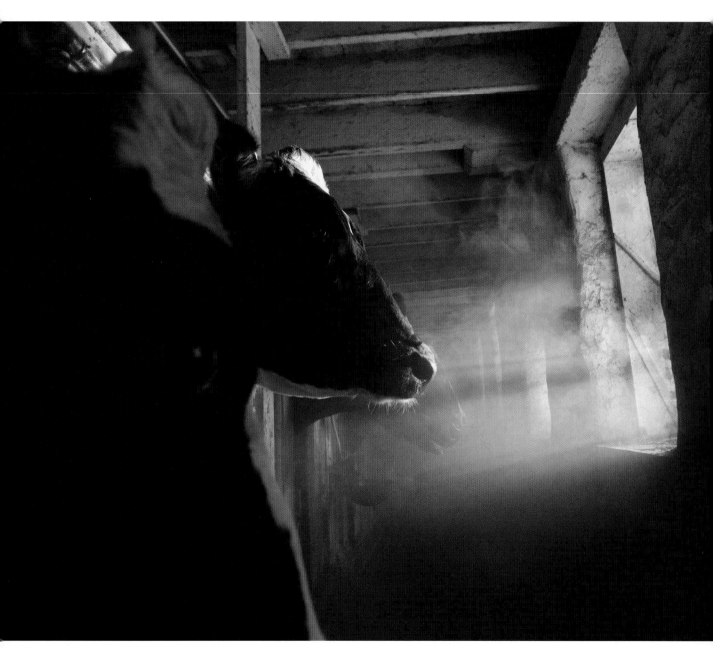

Cows' breath lingers in the chill of the barn.

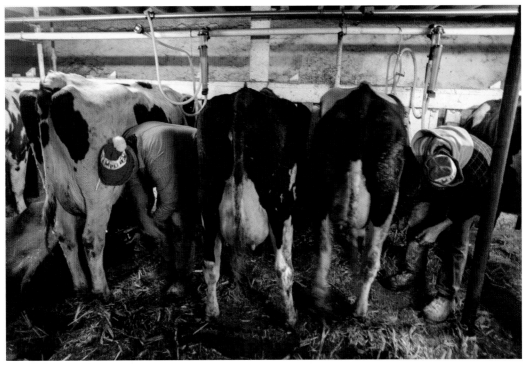

Jim's and Gordy's red stocking caps bob among the cows during the morning milking.

A shaft of early morning light catches
Gordy as he walks through the barn.

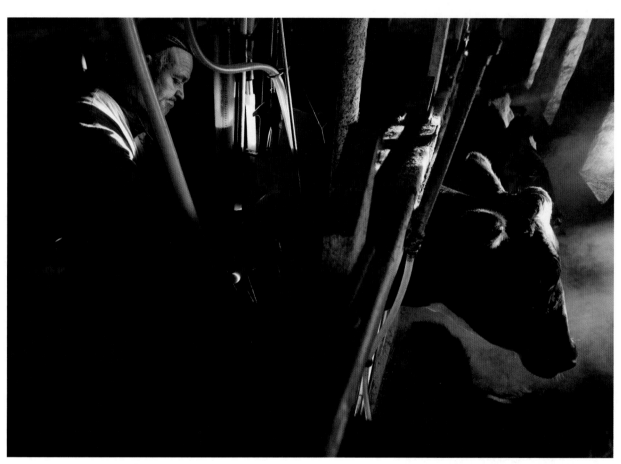

Jim Lamberty presses between two cows during a morning milking.

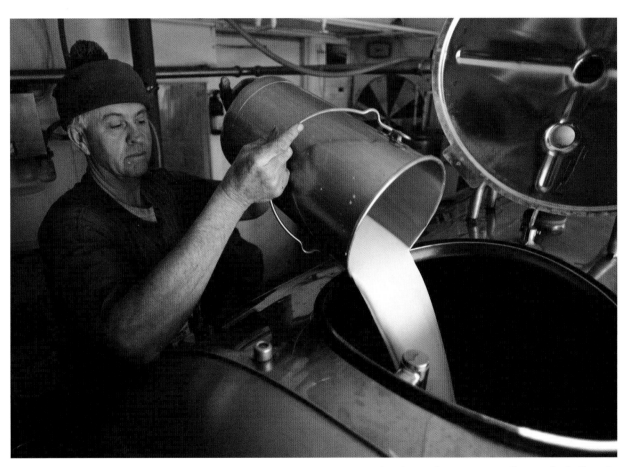

Gordy Lamberty pours milk into the bulk tank.

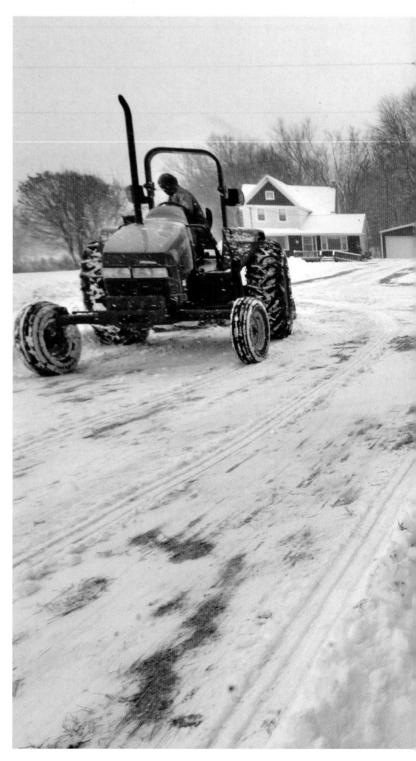

Marie leaves the milking parlor
with a jar of milk to serve with
breakfast as Gordy plows snow, left,
and Jim finishes morning chores.

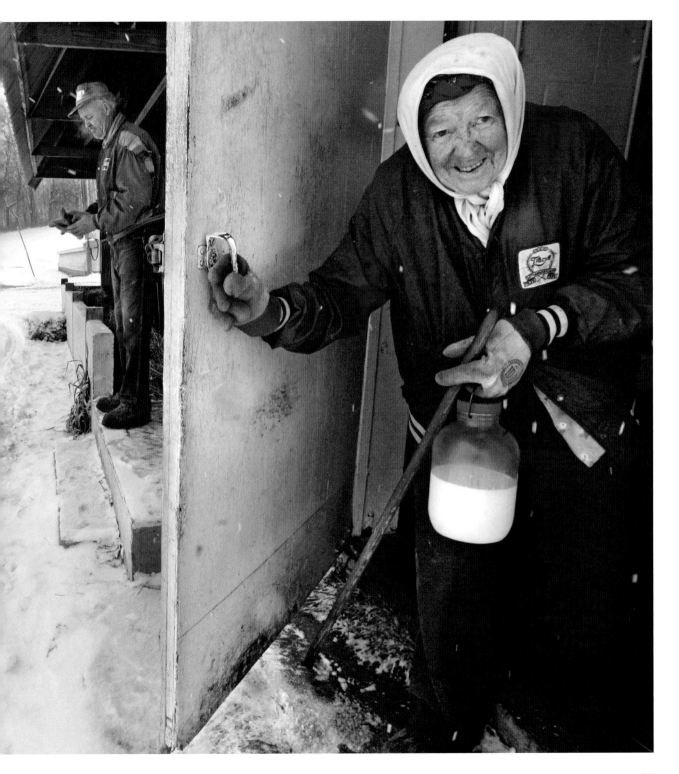

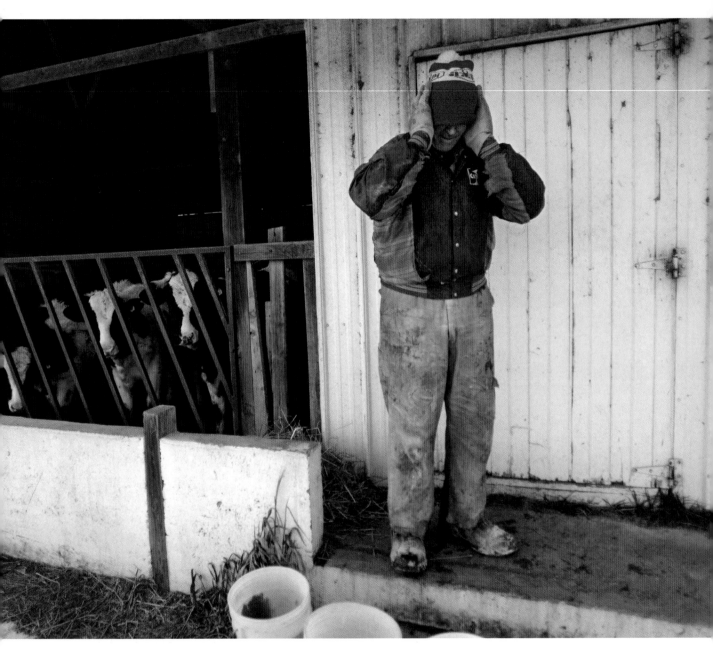

Jim pulls down his hat to guard against the cold as he leaves
the warmth of the barn on a December morning.

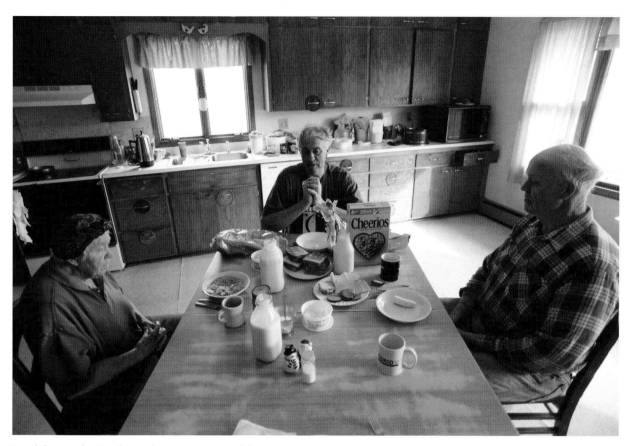

Breakfast on the Lamberty farm starts around 9 a.m., when the morning milking is done. Meals always begin with prayer for the Catholic Lambertys.

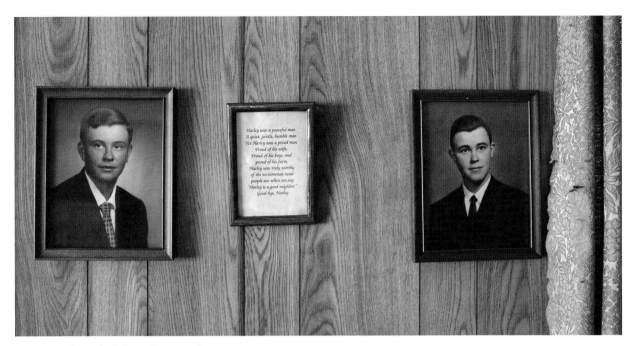

Portraits of Gordy, left, and Jim in their high school days hang on the living room wall. In the middle is a eulogy to their father, Harley Lamberty, that was read at his funeral: "Harley was a peaceful man, a quiet, gentle humble man. Yet Harley was a proud man. Proud of his wife, proud of his boys, and proud of his farm. Harley was truly worthy of the acclamation rural people use when we say, 'Harley is a good neighbor.' Goodbye Harley."

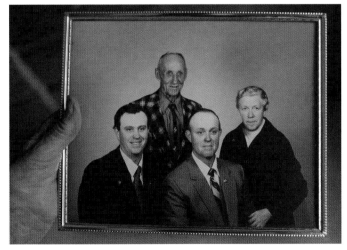

Family portrait, clockwise from top: Harley, Marie, Jim, and Gordy

31

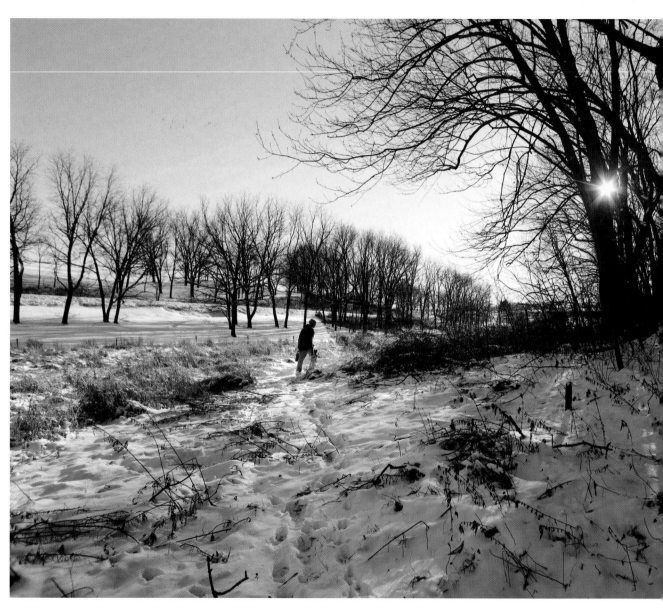

Fieldwork ceases for winter, but there are still jobs to do. Gordy goes to the woods with a chainsaw to cut firewood to heat the farmhouse, where Jim and Marie live.

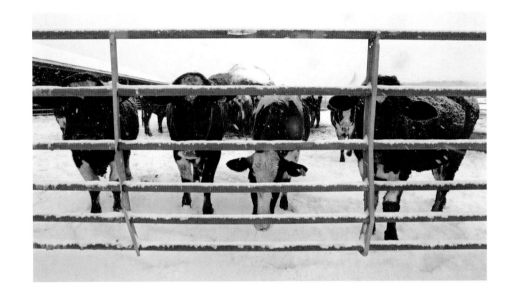

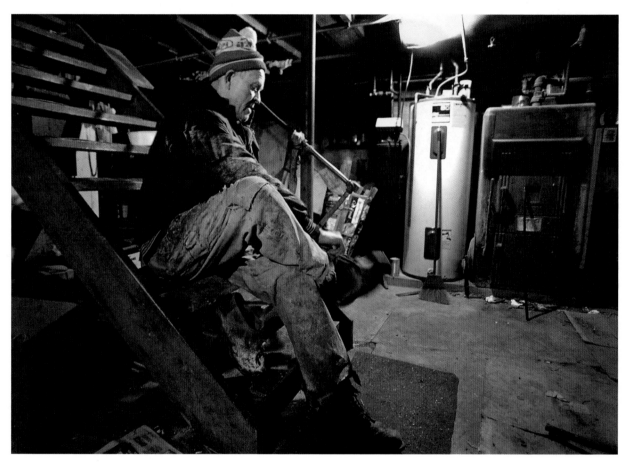

Jim bundles up near the wood-burning stove before
returning to the barn on a January night.

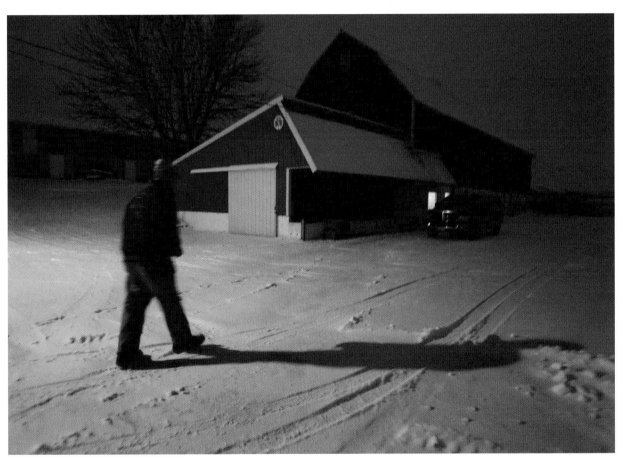

He heads to the barn after dinner to join
Gordy for the evening milking.

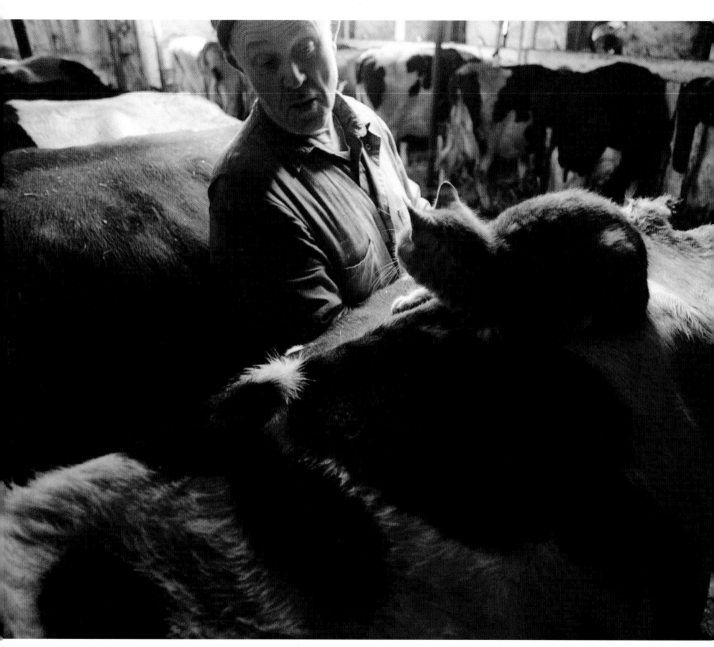

A cat finds a warm spot atop a cow at milking time.

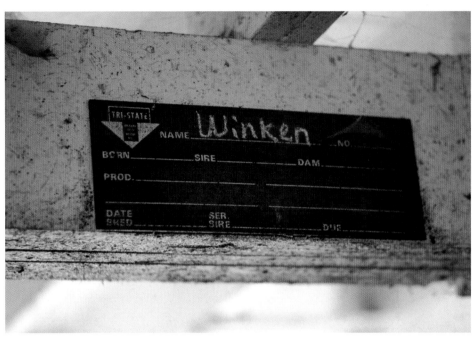

Each cow is given a name on a plaque in the dairy barn.

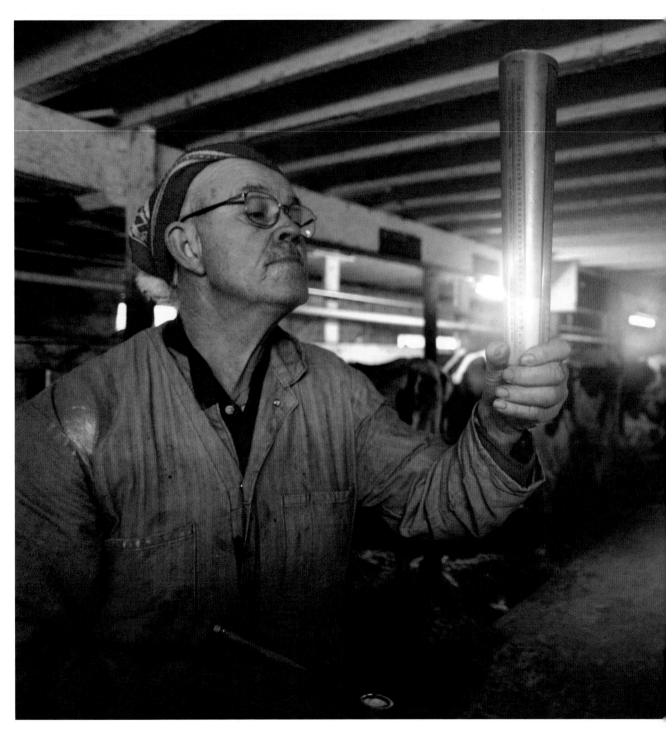

Jim holds a cylindrical beaker used to take samples to measure the milk's butterfat content.

The brothers use a marker to keep track of the
protein content of the cows' feed.

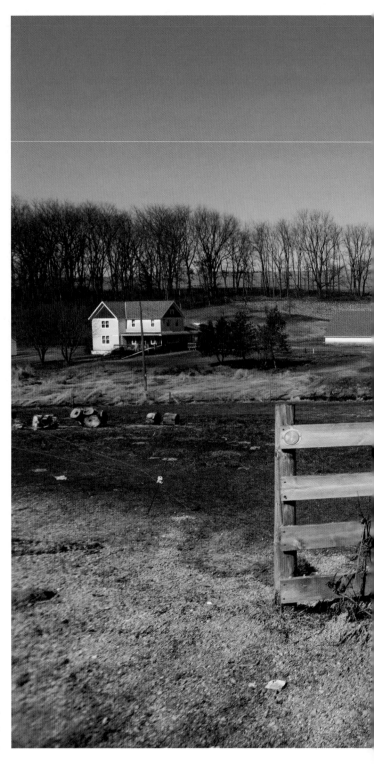

Early spring, when
the first warm breezes
come to the farm

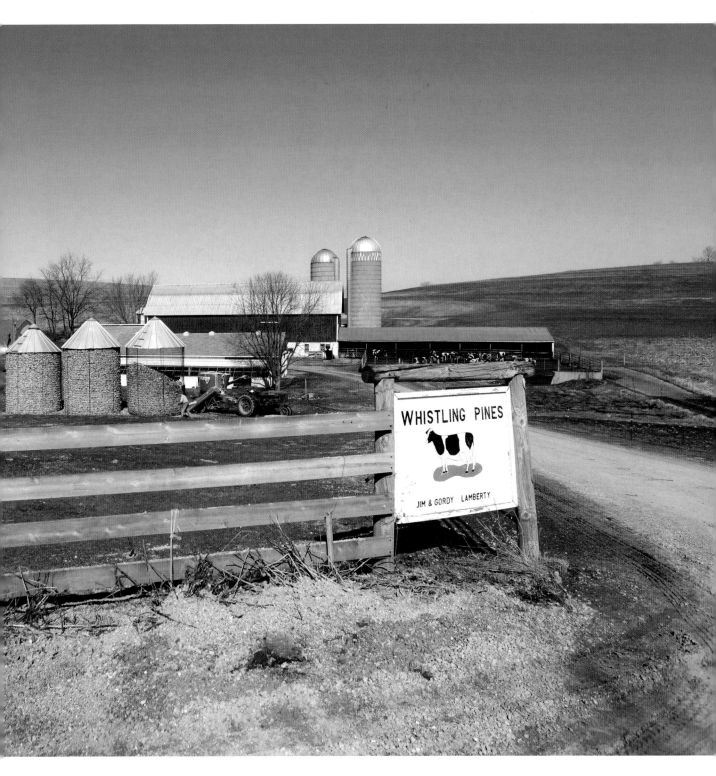

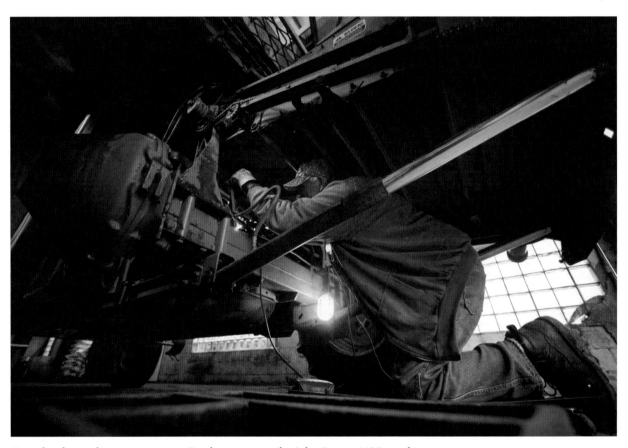

On a day devoted to maintenance, Gordy peers into the John Deere 4420 combine.

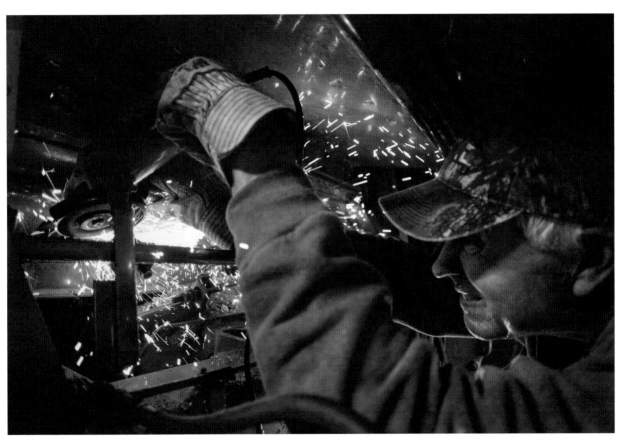

He uses a grinding tool to try to free a frozen bearing.

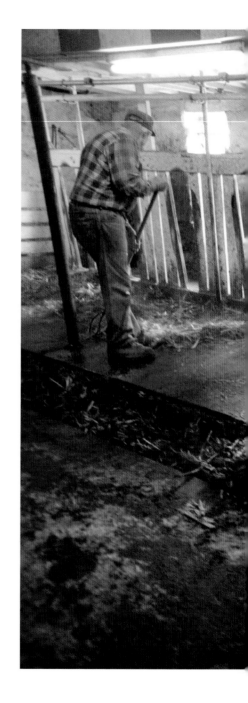

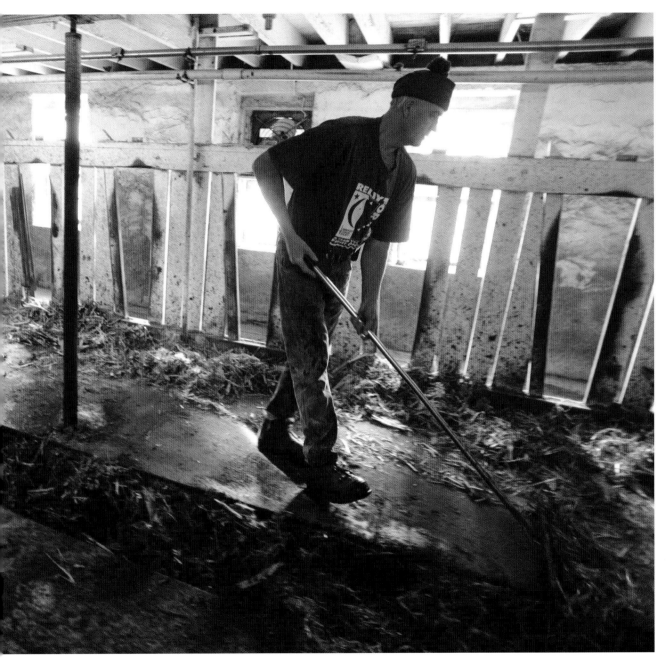

Warm sunshine heats the barn in early spring as the brothers clean up after morning milking. They have used the winter to do maintenance on machinery and will soon return to the fields.

The land wakes up in spring as
Jim prepares a field for planting.

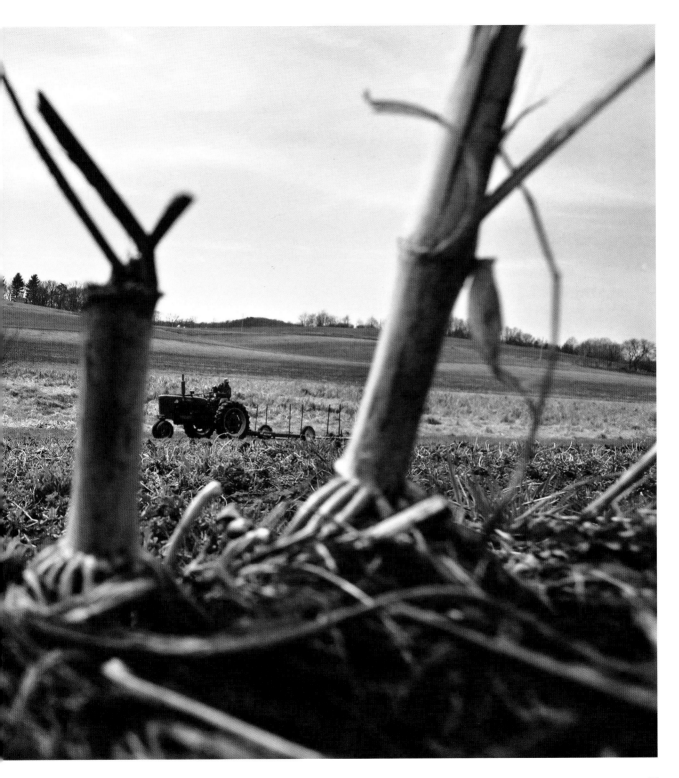

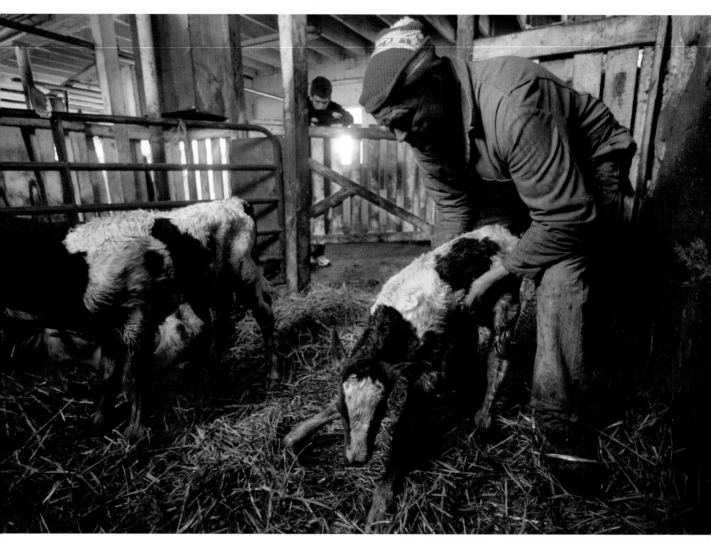

Jim helps a new calf, born the night before, to its feet.

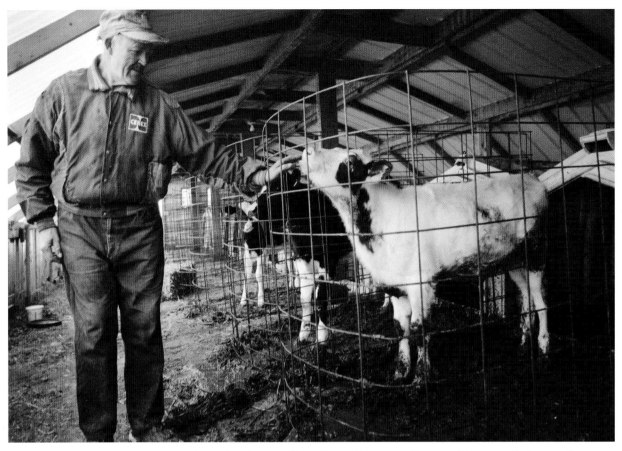

This red Holstein calf caught Jim's fancy and became like a pet. She's named Yvonne.

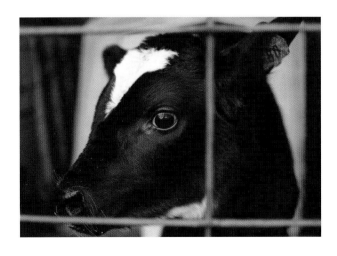

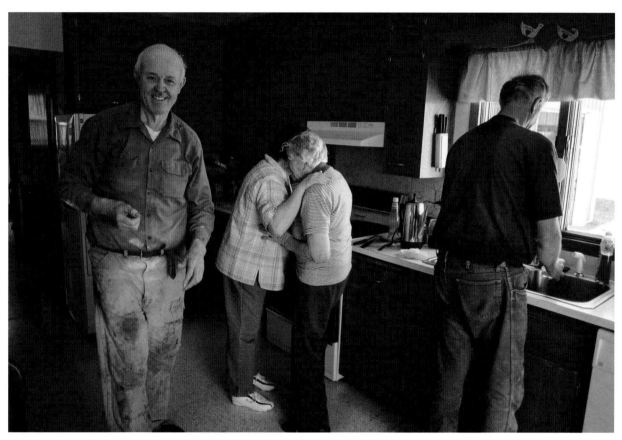

Jim, Vicky, Marie, and Gordy share a happy moment in the kitchen
about a week before Gordy and Vicky's wedding.

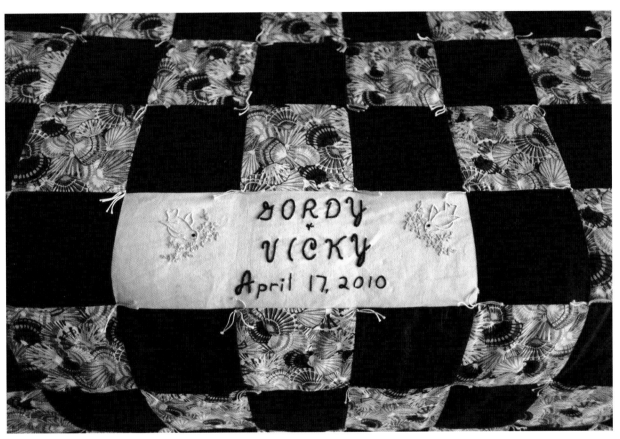

A quilt made as a wedding gift for Vicky and Gordy

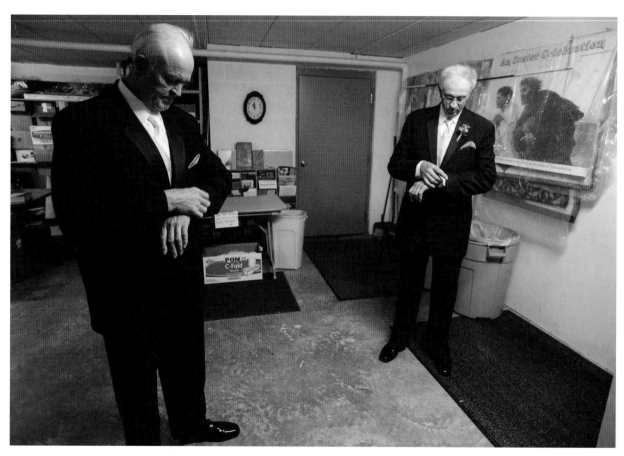

Jim, left, and Gordy check their watches in a room at
St. Mary of Pine Bluff Catholic Church before Gordy's
wedding. Jim is Gordy's best man.

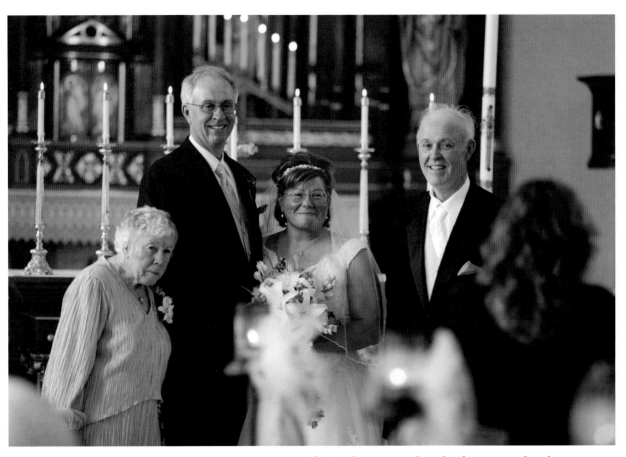

The Lambertys pose for a family portrait after the ceremony.

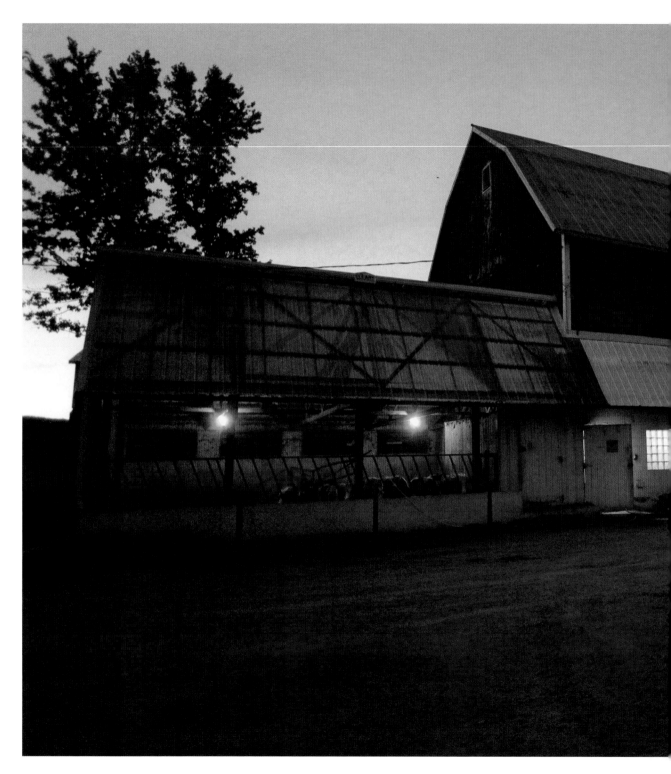

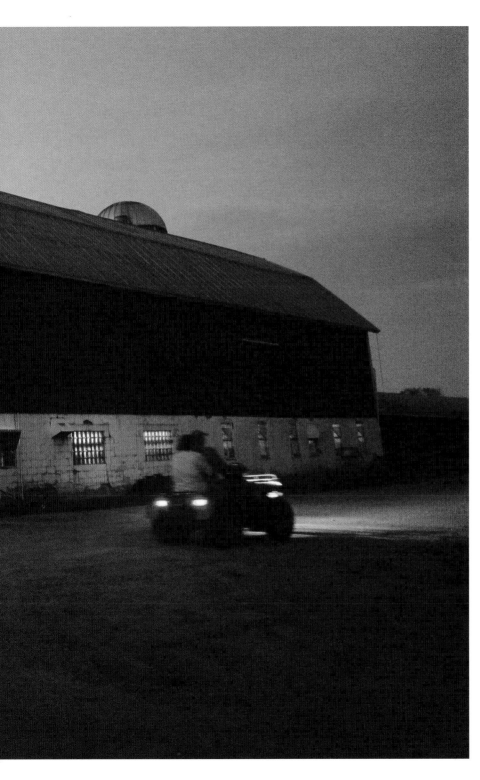

Vicky and Gordy Lamberty.
When they were dating,
Vicky knew that the only
way she would be able to see
Gordy was to work beside
him on the farm.

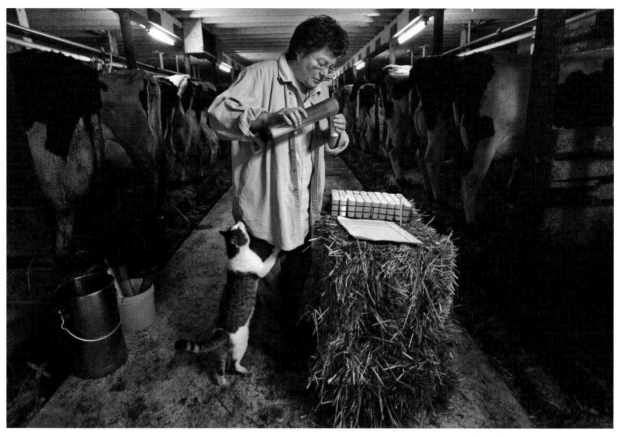

Vicky collects milk samples for the monthly butterfat test,
as a barn cat hopes for a sample of its own.

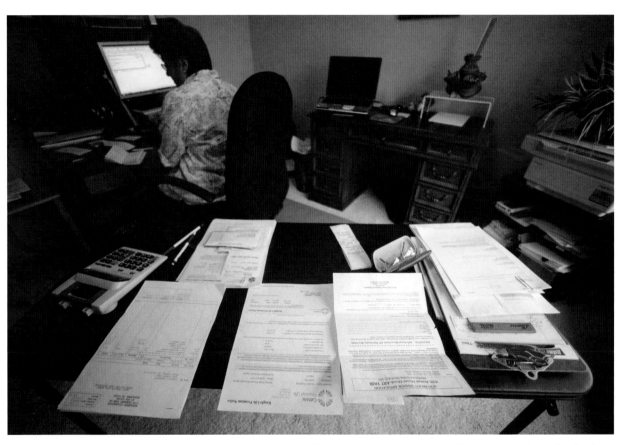

Her experience in business administration brought the farm
up to date with electronic recordkeeping.

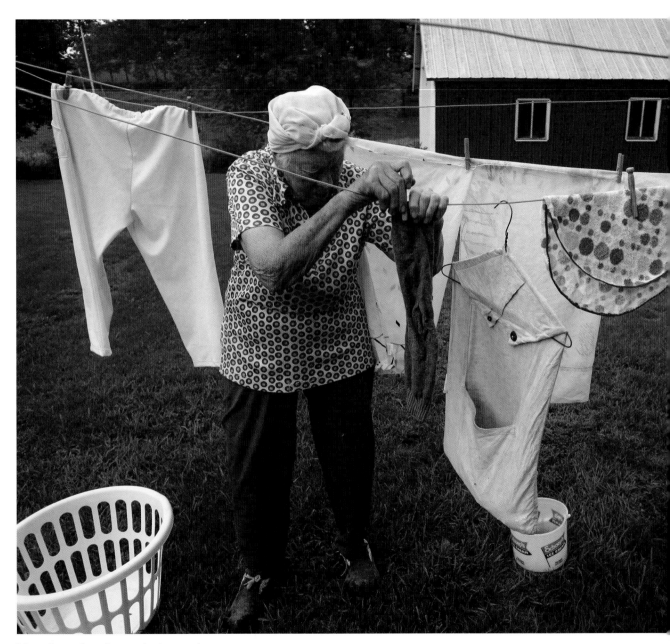

Marie hangs laundry on the line to dry.

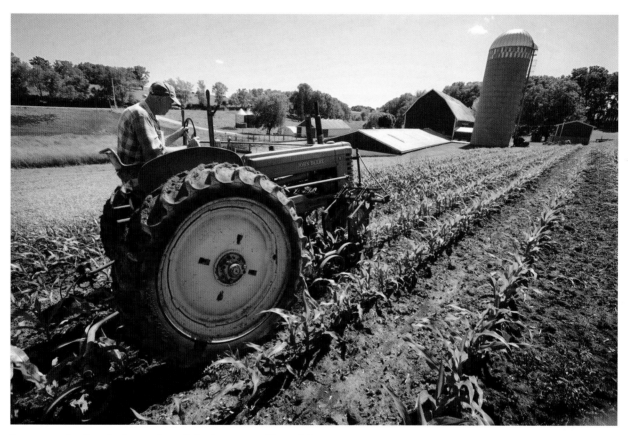

In a scene that hasn't changed much in sixty years, Jim cultivates corn with a 1948 John Deere B farm tractor and a two-row cultivator.

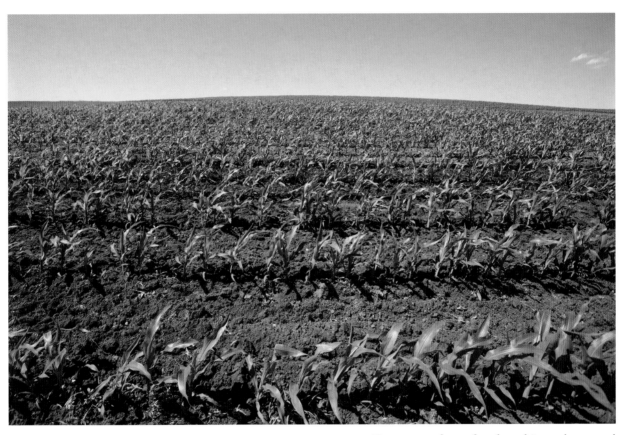

Young corn plants after the cultivator has passed

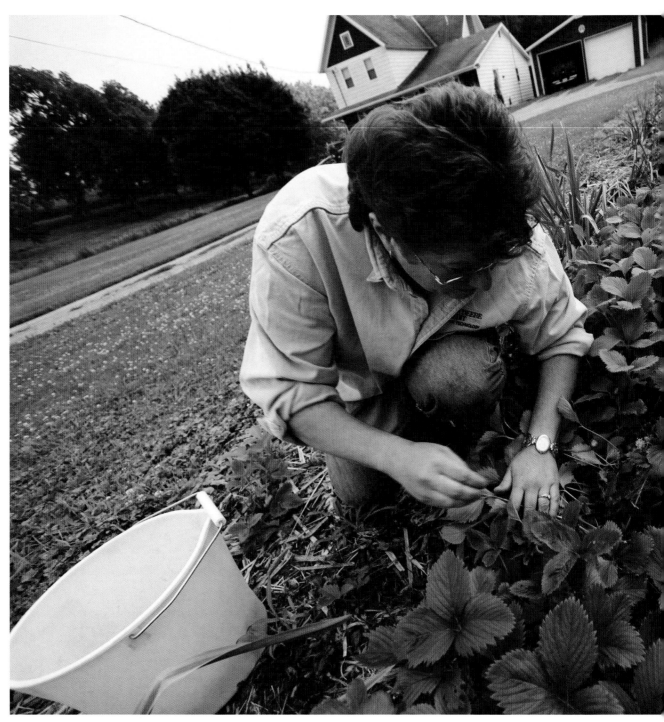

Vicky picks strawberries for jam.

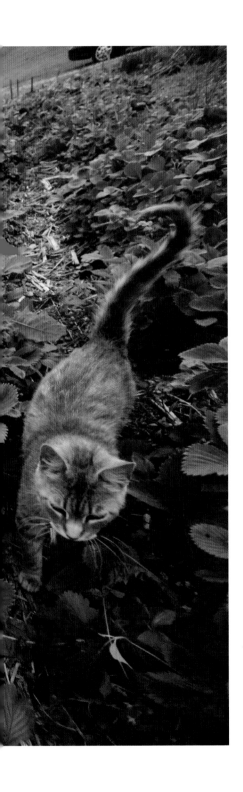

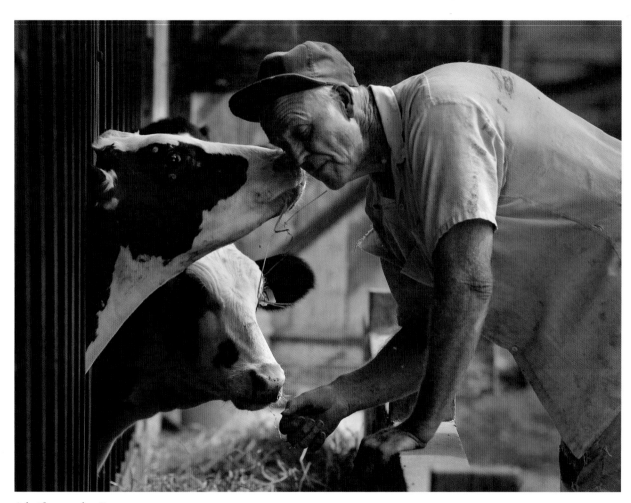

A heifer nuzzles Jim.

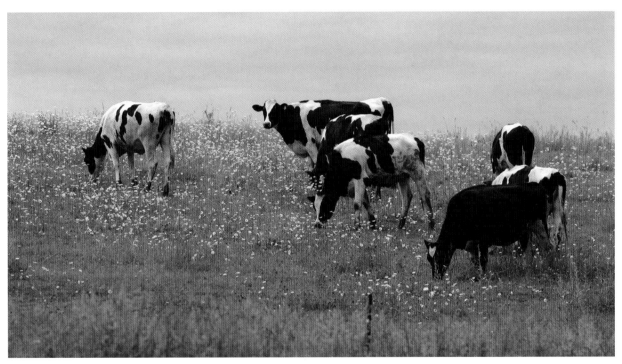

The livestock forage for grass on a summer day.

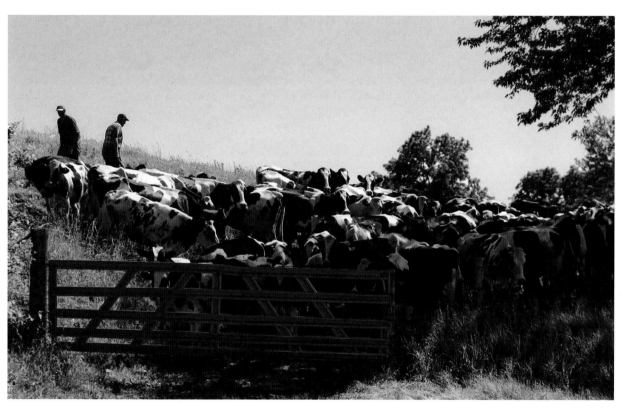

Gordy, left, and Jim gather the herd from the
pasture for the evening milking.

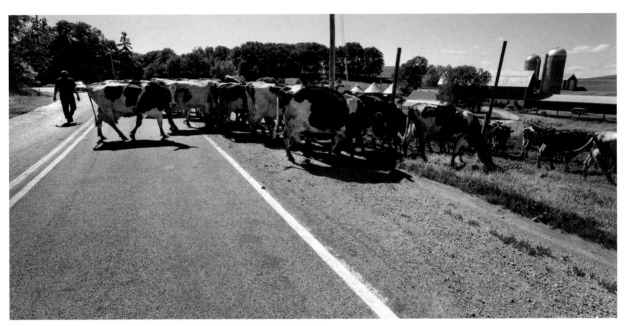

Traffic along Highway J pauses as the brothers move the cows from the pasture to the farm.

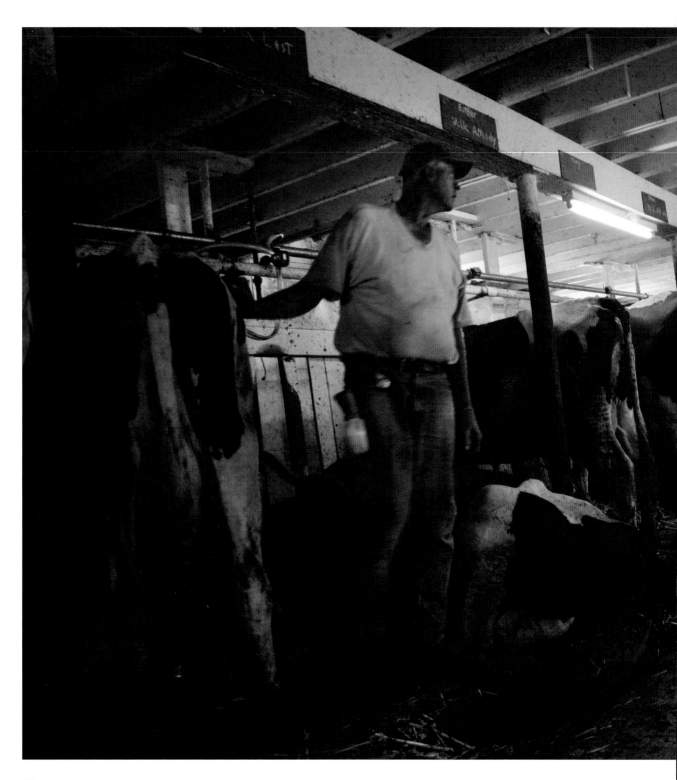

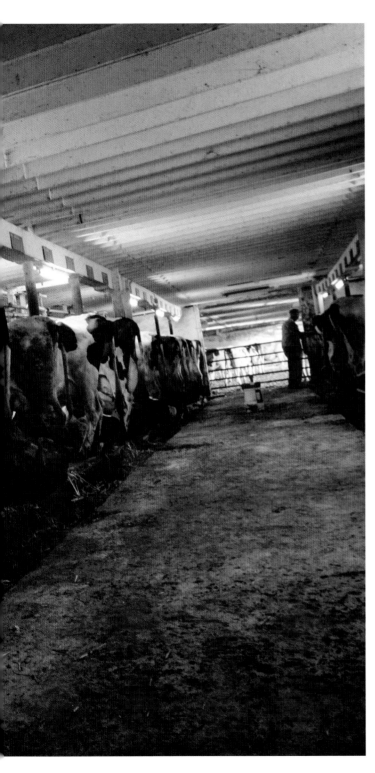

Gordy, left, checks on Jim
as they finish milking on a
summer evening.

Milk truck driver Rick Edwards picks up the Lambertys'
milk for delivery to a cheese factory.

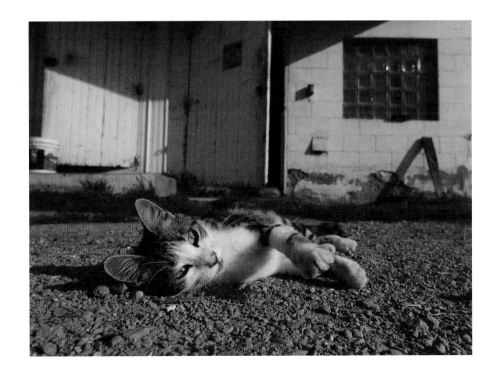

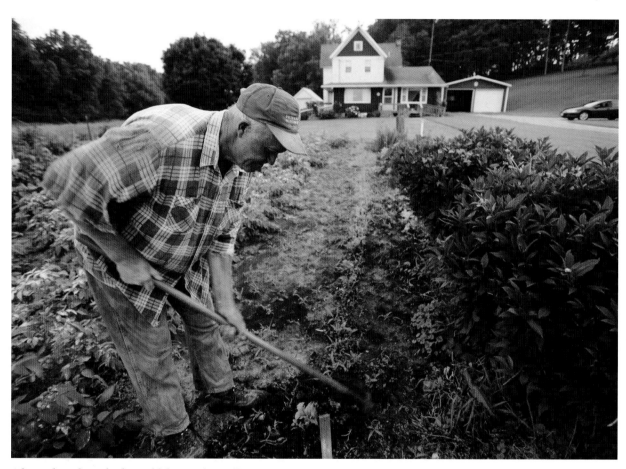

After a day of tough physical labor with Gordy,
Jim hoes the vegetable garden before going into
the house for the night.

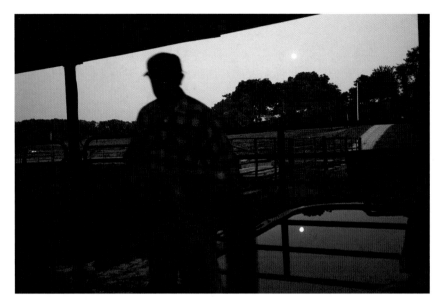

The last job of the day
is to fill a tank with
water for the cows.

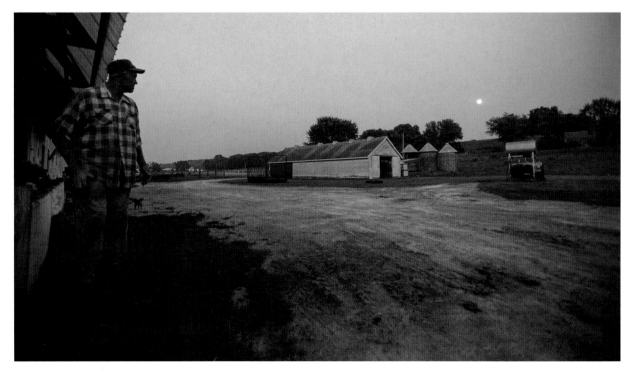

Jim pauses for a last look over the farm as the moon rises.

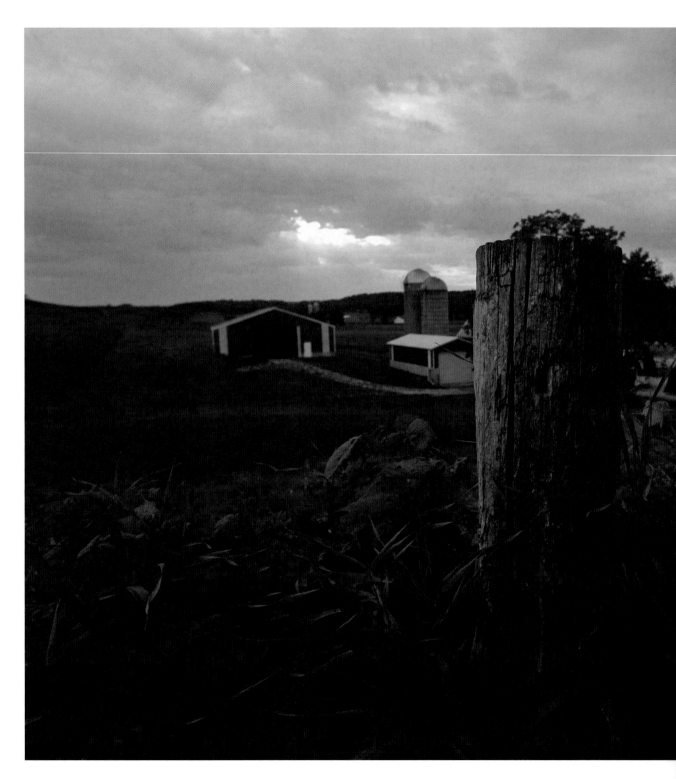

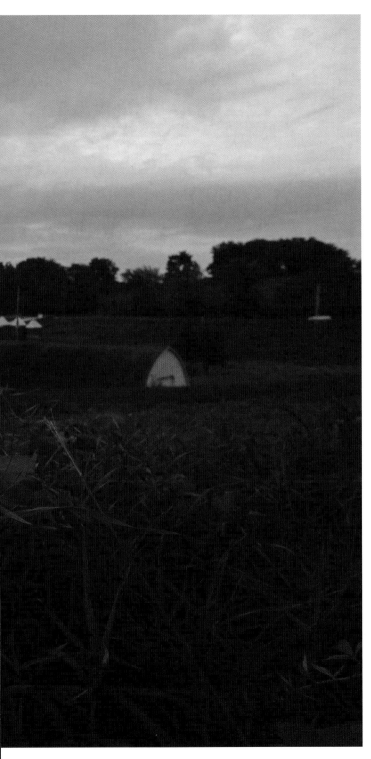

Dawn

Oat field in summer

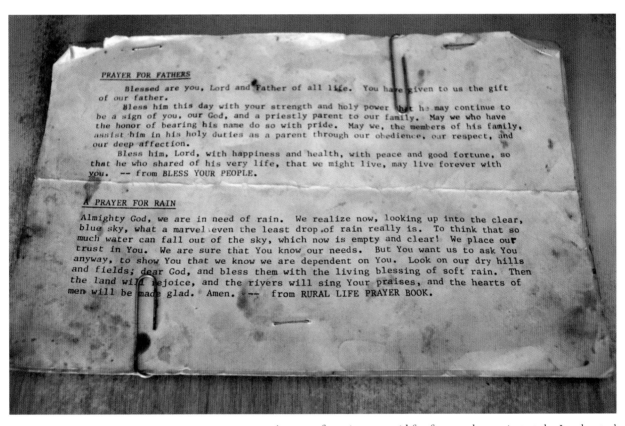

PRAYER FOR FATHERS

Blessed are you, Lord and Father of all life. You have given to us the gift of our father.

Bless him this day with your strength and holy power that he may continue to be a sign of you, our God, and a priestly parent to our family. May we who have the honor of bearing his name do so with pride. May we, the members of his family, assist him in his holy duties as a parent through our obedience, our respect, and our deep affection.

Bless him, Lord, with happiness and health, with peace and good fortune, so that he who shared of his very life, that we might live, may live forever with you. -- from BLESS YOUR PEOPLE.

A PRAYER FOR RAIN

Almighty God, we are in need of rain. We realize now, looking up into the clear, blue sky, what a marvel even the least drop of rain really is. To think that so much water can fall out of the sky, which now is empty and clear! We place our trust in You. We are sure that You know our needs. But You want us to ask You anyway, to show You that we know we are dependent on You. Look on our dry hills and fields, dear God, and bless them with the living blessing of soft rain. Then the land will rejoice, and the rivers will sing Your praises, and the hearts of men will be made glad. Amen. --- from RURAL LIFE PRAYER BOOK.

A prayer for rain once said for farmers by a priest at the Lambertys' church in Pine Bluff is taken out and prayed during a serious drought.

Test corn plots

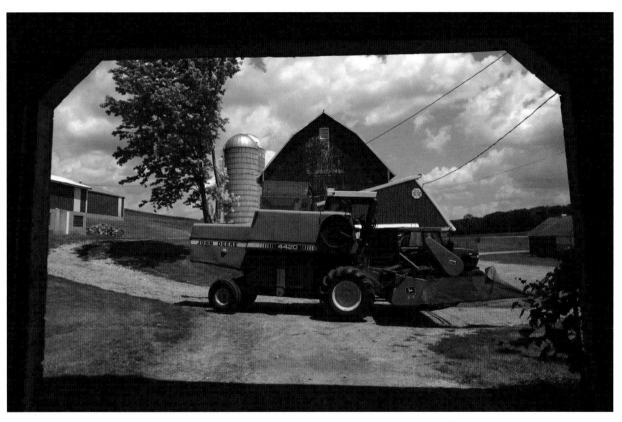

Gordy drives the John Deere 4420 out to the field to harvest oats.

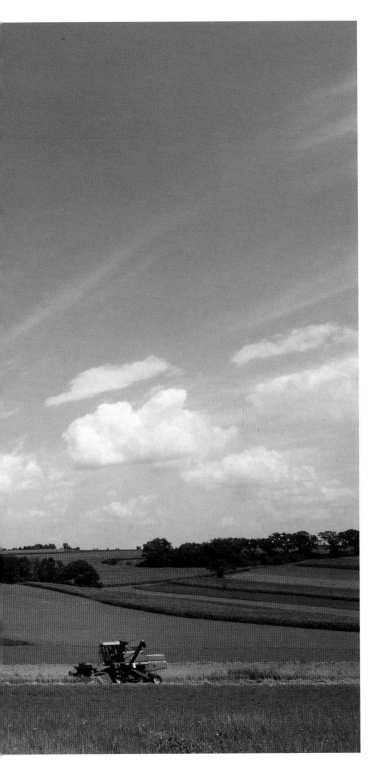

Oats harvest, late July

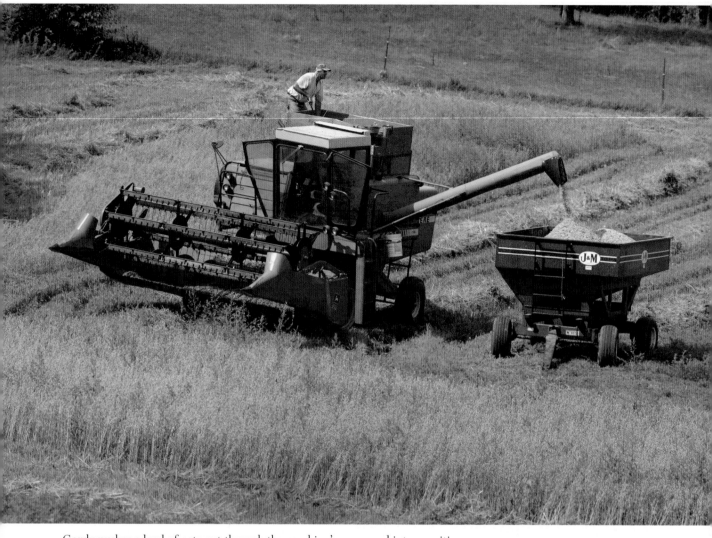

Gordy pushes a load of oats out through the combine's auger and into a waiting wagon.

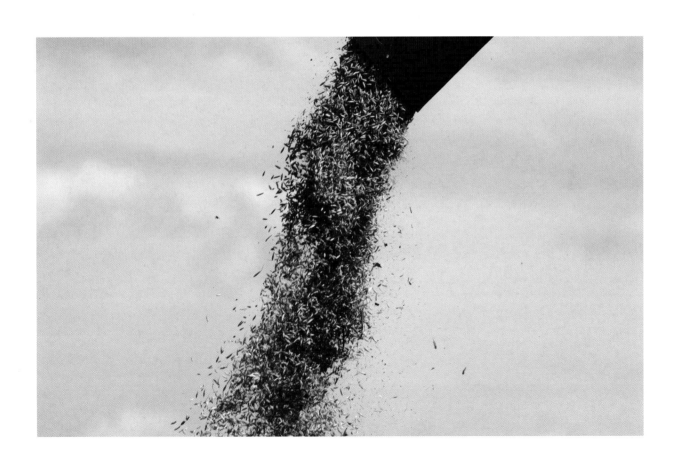

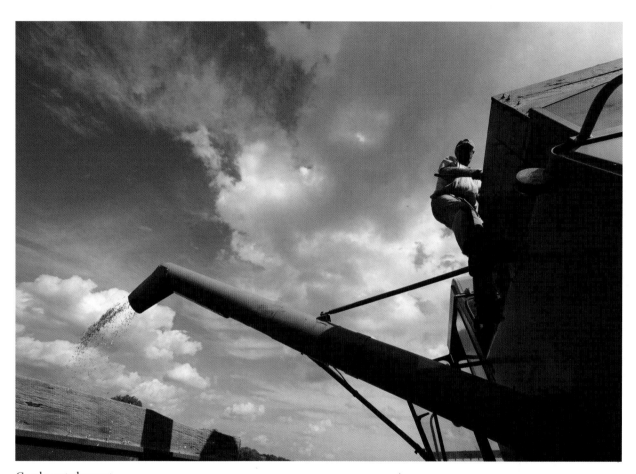

Gordy, oats harvest

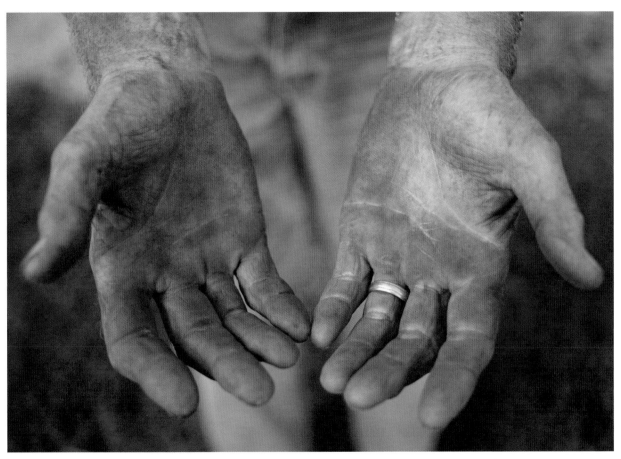

It's often said that the eyes are the windows to the soul, but I think the hands, especially the hands of working people like Gordy Lamberty, have just as much to tell.

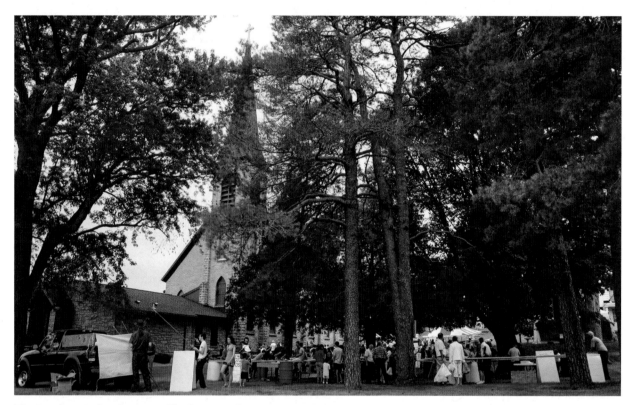

The Lambertys do take time off, often to volunteer at community
and church events like the annual parish festival at St. Mary of
Pine Bluff Catholic Church.

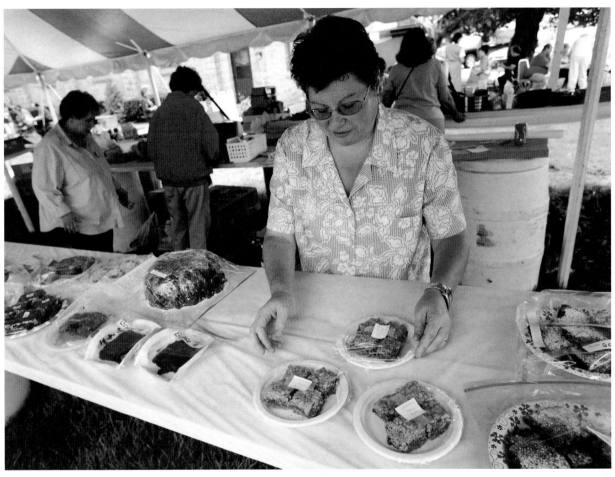

Vicky sells homemade cookies, pics, and cakes at the festival.

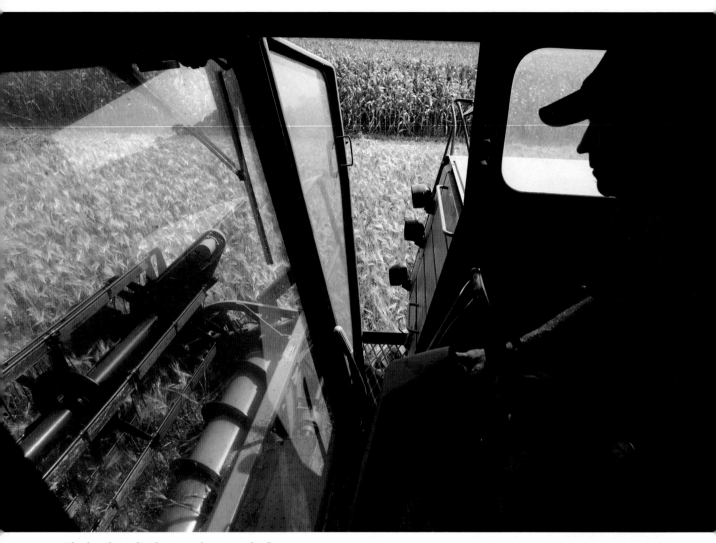

The brothers divide some duties on the farm.
Gordy, here harvesting barley, is always at the
helm of the combine.

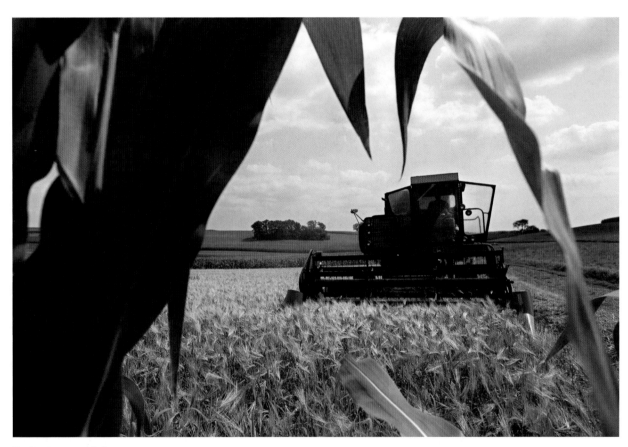

Barley harvest, July

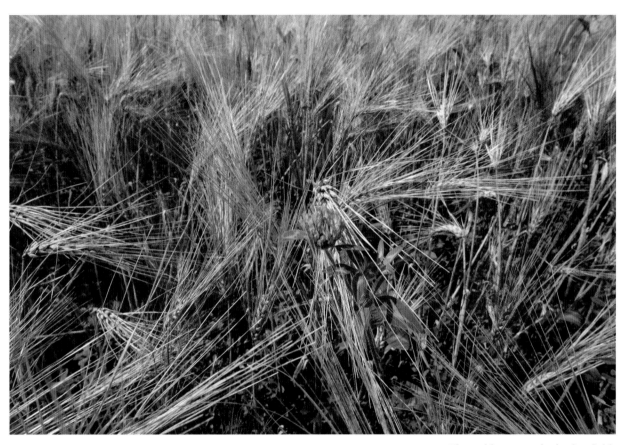

Clover blooms in the barley field.

On a warm and dry midsummer day,
the alfalfa and corn are ripening as
Gordy heads into the shop building
on the hill above the farmhouse.

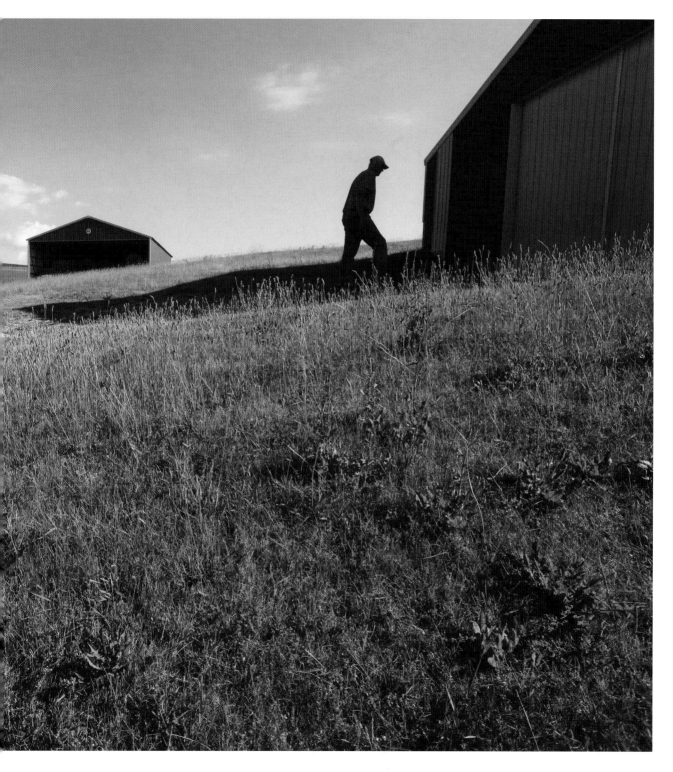

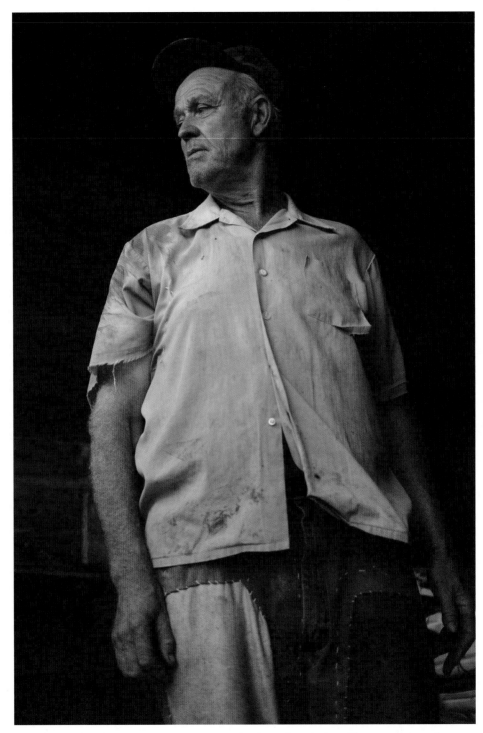

Even in patched and worn work clothes, Jim looks as dignified as if he is wearing a fine suit.

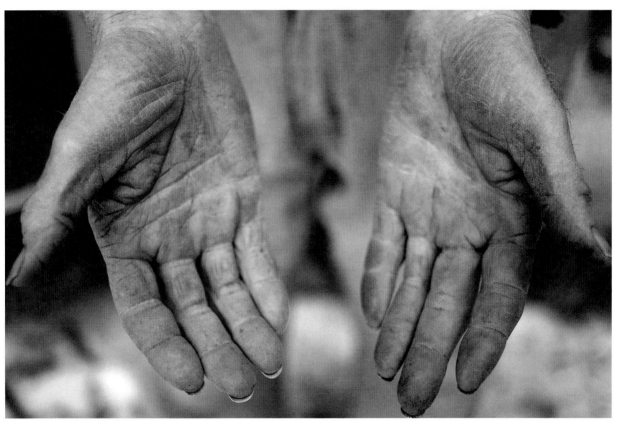

His hands testify to decades of labor.

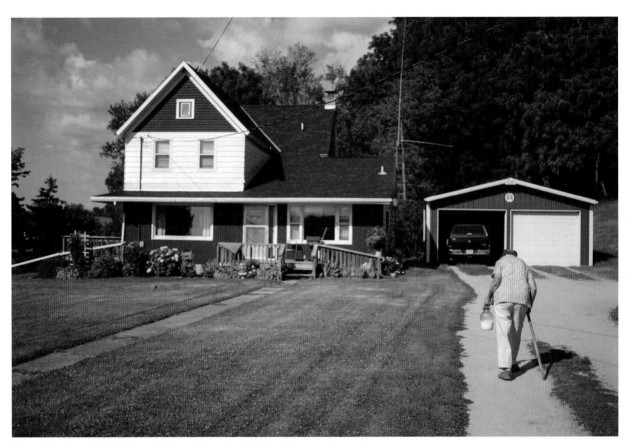

Marie heads to the house to fix breakfast after helping her sons in the barn.

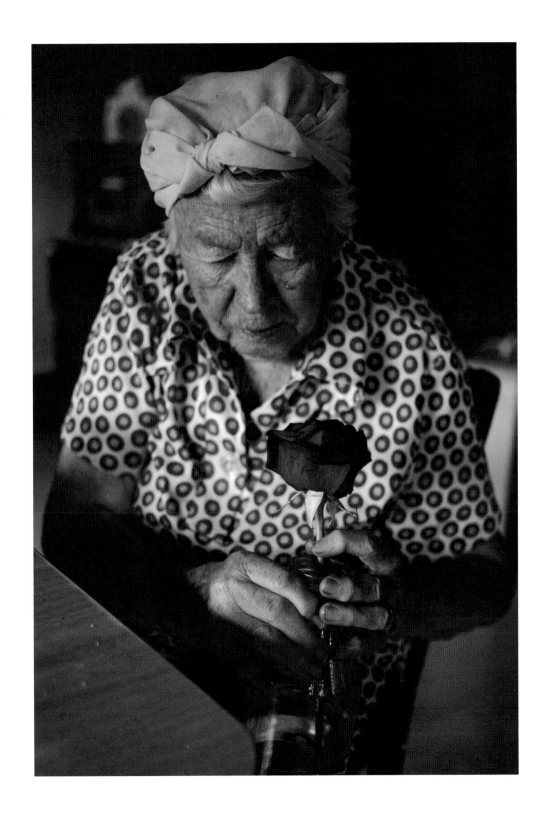

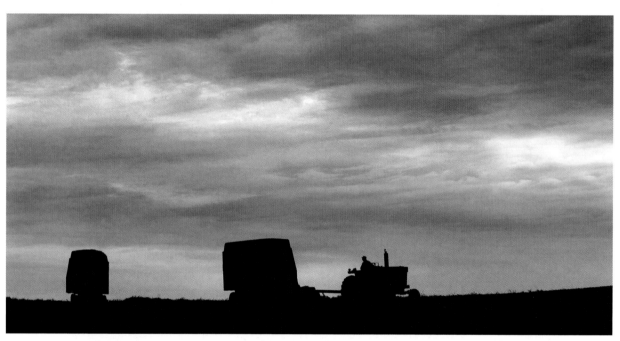

Jim chops hay to fill the silo.

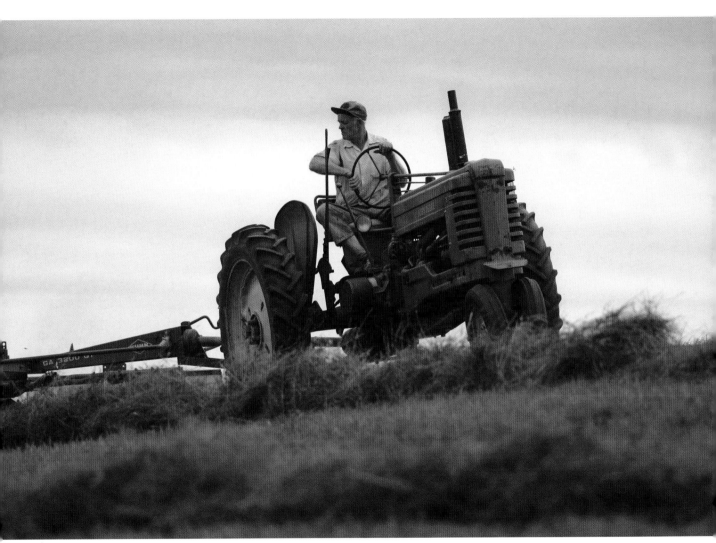

He rakes the hay into windrows for round bales.

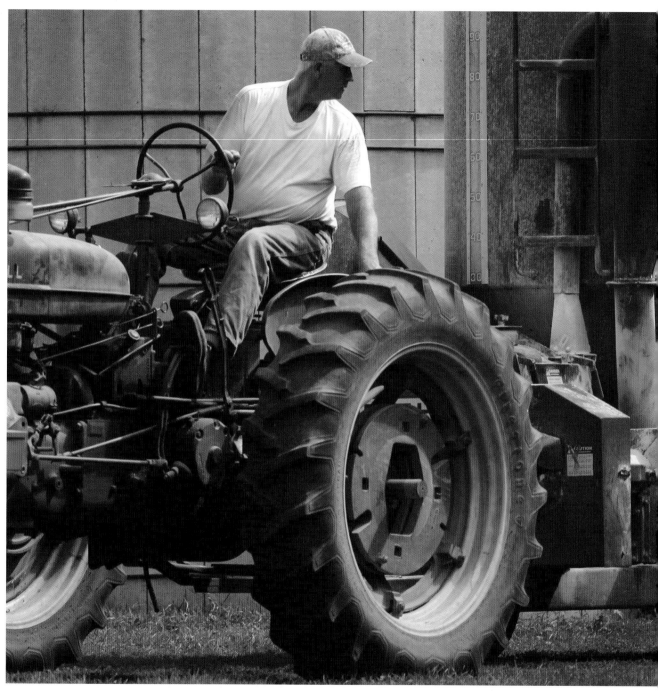

After putting a load of ground feed into the barn, Jim, right, swings the auger clear of the building so Gordy can move the grinder. The brothers have worked together since they were boys.

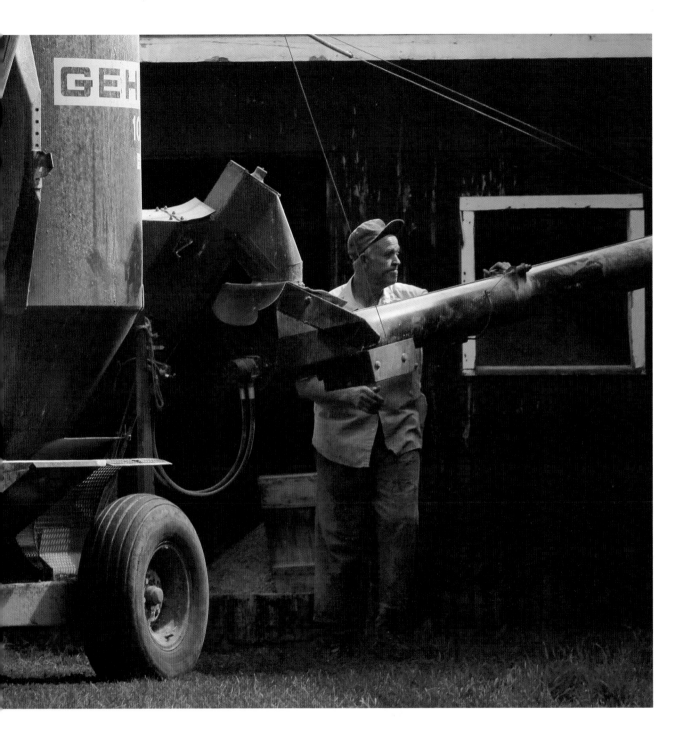

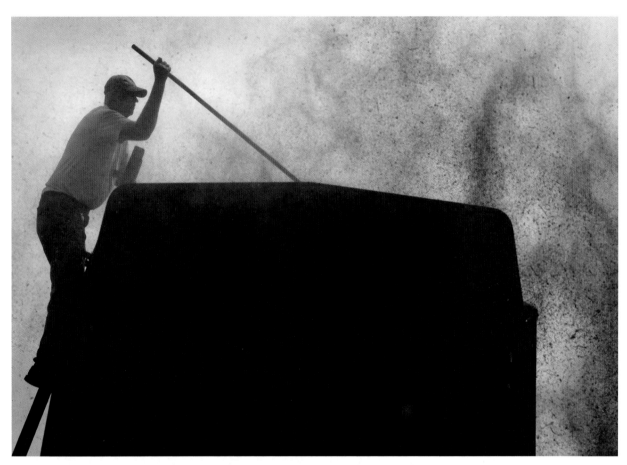

Showing the meticulous way the brothers care for their equipment, Gordy pauses while filling a silo to sweep chopped hay residue off the top of the wagon so the accumulated debris does not promote rust and mold.

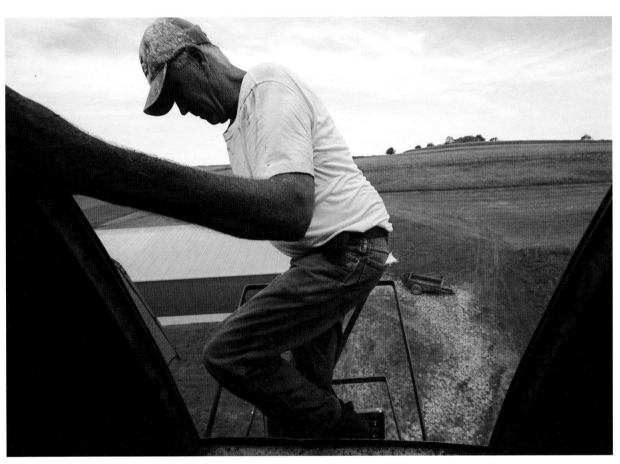

He climbs a ladder fifty feet to the top of the full silo, where
he will use a pitchfork to level off the pile of chopped hay.

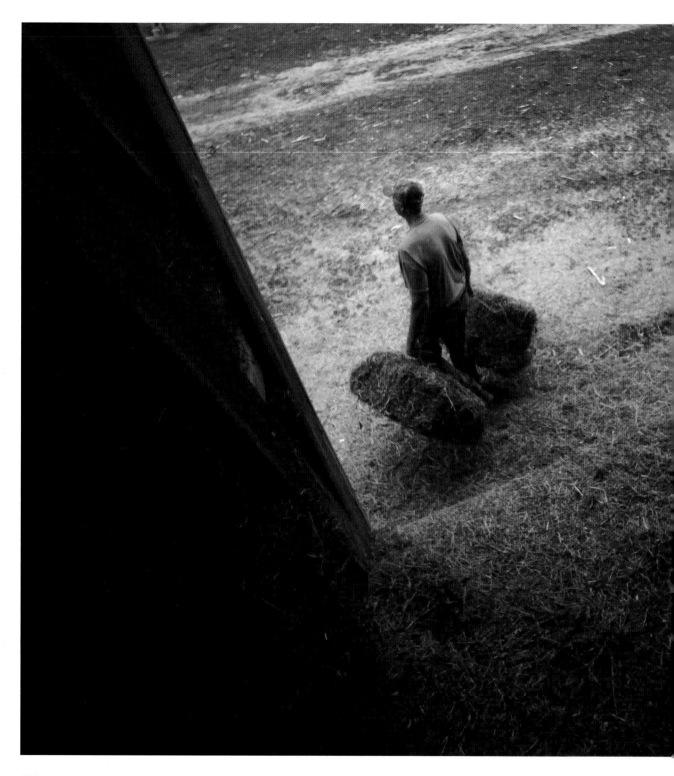

Gordy, seen from the hayloft

Marie's work coat. The family's work clothing is patched and sewn instead of discarded.

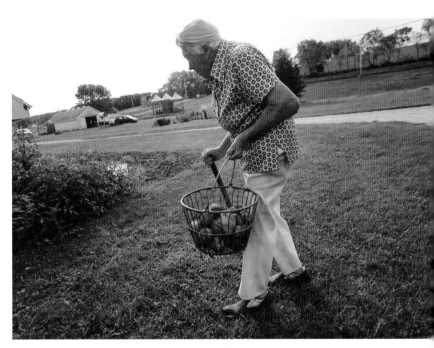

Marie takes potatoes to the machine shed for drying.

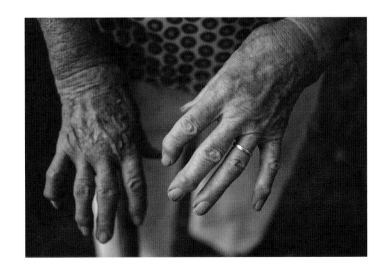

The waning light of a November
afternoon catches Jim as he watches
the corn picker from his tractor seat.

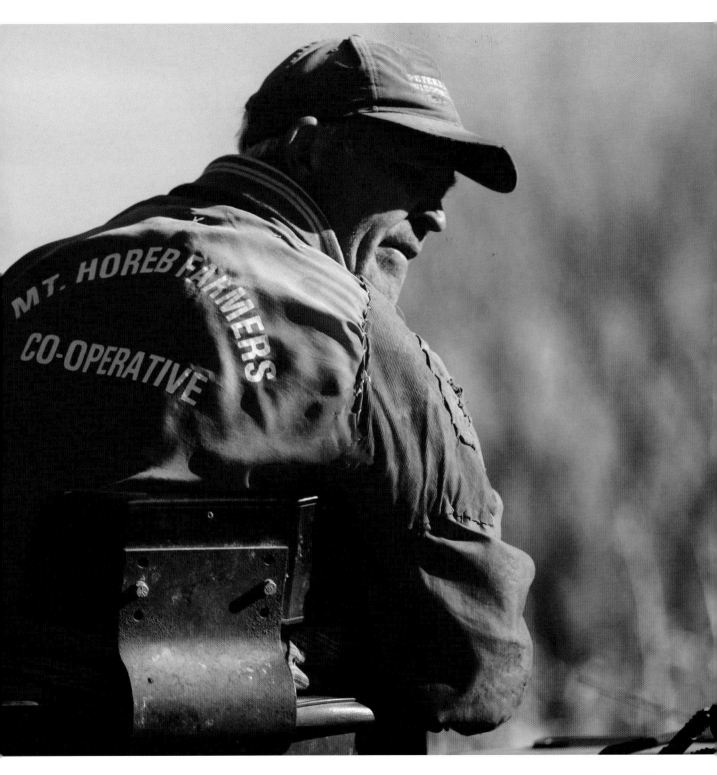

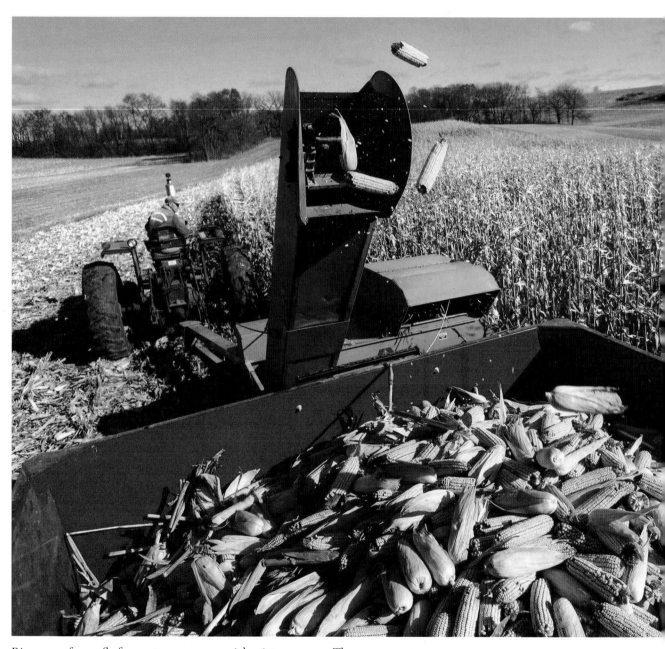

Ripe ears of corn fly from a two-row corn picker into a wagon. The ears are put
in corn cribs to be ground throughout the year into feed for the dairy herd.

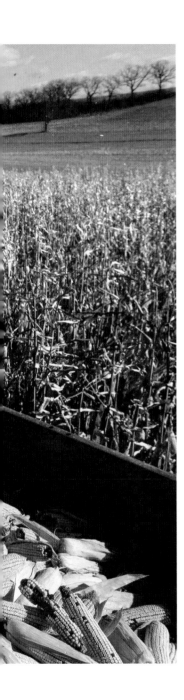

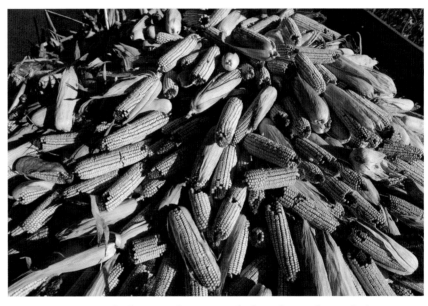

The harvest of 2010 was the best the Lambertys had ever seen.

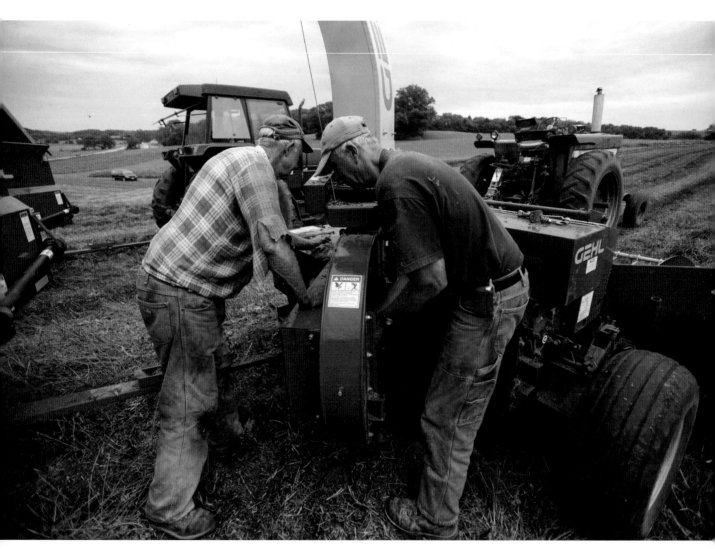

The brothers team up to resolve an equipment failure. They have the skills
to fix most problems on site or in the shop at the farm.

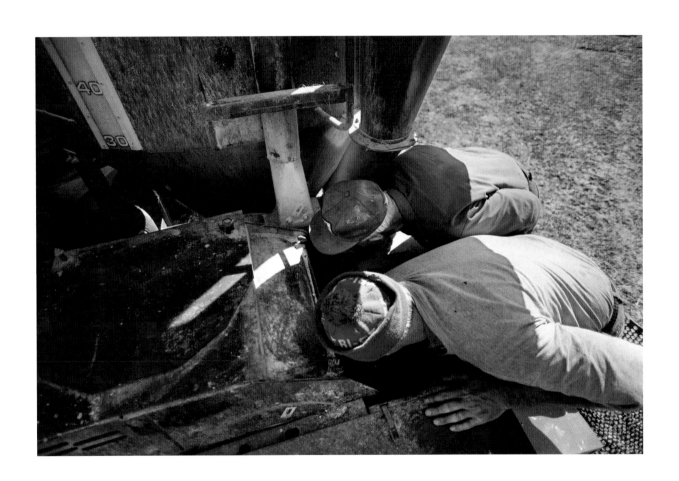

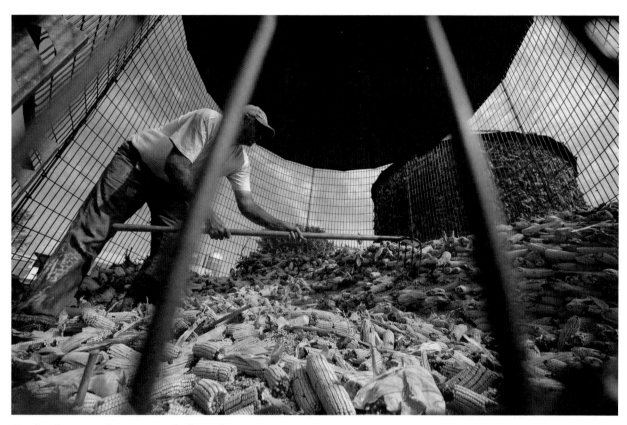

Gordy rakes ears of corn into a feed grinder.

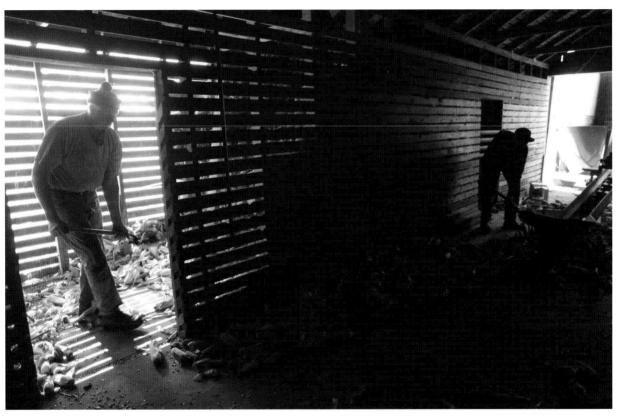

Gordy, left, and Jim shovel corn into the grinder.
Their methods are traditional and labor intensive.

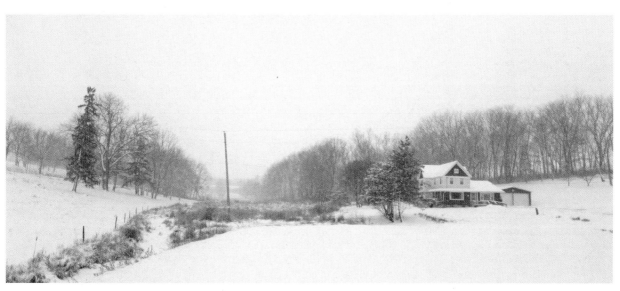

Light snow falls on the Lamberty farm.

EPILOGUE

On a Saturday night in May 2012, Jim Lamberty phoned me from the farm. There was going to be an exhibit of antique farm machinery the next day on the site of a long-departed Cross Plains farm implement dealer, and Jim was driving his 1948 John Deere B into town to put it on display. I could come and take pictures if I wanted to, Jim said. It had been a while since I had been to the farm, and I was glad to keep the connection going.

The next morning, I drove to Pine Bluff. I thought I might catch Jim before he left the farm—but what I really wanted was a photograph of him on the road.

Approaching Pine Bluff from Madison on Mineral Point Road, the village's most prominent feature is the spire of St. Mary of Pine Bluff Catholic Church. I drove into town, passed the church, and there was Jim riding on the B, right on schedule, heading toward Cross Plains. Jim and Gordy had been using the old tractor that week to cultivate corn, and the B was dusty from the field, with the two-row cultivator still attached. That old tractor may be an antique, but it's a proud working machine. I turned around in a driveway and sped past the tractor a mile or two to where the road gradually rises to a high hill, providing the perfect spot to make a picture of Jim and the tractor with the little town in the background.

I left my van, stood in the ditch by the side of the road, and waited. It didn't take long for the tiny, slow-moving dot in the distance to start looking like a tractor, then a man and a tractor. A minute later came the unmistakable sound: the crisp, almost cheery "poppity-pop" of an early John Deere.

On they came. Steady as she goes. Poppity-pop.

Highway P coming out of Pine Bluff is a two-lane county highway, but it is a busy highway. I began to notice the traffic, which suddenly made Jim and the tractor look very small and vulnerable. Giant pickup trucks, speeding cars, and loud motorcycles roared past. I could not escape the thought of how out of place Jim and the tractor looked. They seemed caught in a big, fast, dangerous, reckless world that could wipe them away in an instant.

But on they came. Steady as she goes. Poppity-pop.

In the months after I took that picture, a drought would devastate crops in southern Wisconsin and across the lower two-thirds of the United States. The Lambertys felt the effects of the drought, but they were able to grow enough on their own land to feed their stock, maintain their dairy herd, and continue to produce and sell milk.

In the late summer of 2012, the brothers were resigned to another winter of milking the dairy herd. The drought had made feed prices jump, and many farmers were getting rid of livestock at bargain prices. Jim and Gordy had worked too hard at creating a first-rate dairy herd to let the cows go cheaply or to see the herd split up. They cared about the cows and wanted them to stay together. The brothers would wait. Or so they thought. But in September, a surprise came in the form of a young farmer from Darlington who shared their

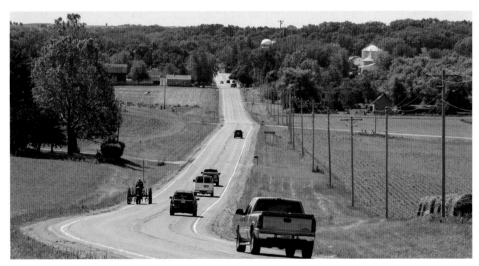

Jim drives the John Deere B out of Pine Bluff.

views on dairying in the small farm tradition and who was putting together a new herd. After the morning milking on a perfect day, September 29, 2012, a truck arrived to take away the last of the cows.

After the cows were loaded and gone and the paperwork was done, sunlight streamed into the empty barn as the brothers scraped away the bedding and manure from the morning milking for the last time. The barn seemed especially quiet that day.

It was the end of a long chapter at Whistling Pines Farm. But it was not the end of the story.

I talked with Jim during the second week of March 2013. The brothers are feeding calves, heifers and steers, all Holsteins. They have about as many animals as they did when they were milking, but without the immense responsibility of tending a dairy herd. Marie has moved to a retirement home not far away. She goes to the farm once a week now. This year neat strips of corn, beans, oats, and alfalfa will appear again along the gentle slopes of Whistling Pines Farm. Jim, Gordy, Vicky, and Marie are beginning a new chapter as the story of the farm goes on.

Faith in God. Personal responsibility. Making do. Pulling together. Avoiding debt. Relying on one's own manual labor. The value of an educated guess. Nurturing the land and the animals. Do all of these add up to success? For the Lambertys, they did.

The history of farming is still being written. This book is a snapshot in time of one small farm. Really, it is a book about work and a way of living. Its purpose is not to compare small farms and big farms. Gordy Lamberty himself will tell you that one is no better than the other. Success, he has said, is all in how each farm is managed. But history may yet show that the Lamberty way was one of the most effective ways.

ABOUT THE AUTHOR

Zach Schreiner

Craig Schreiner's connection to farming and to rural people began when he was a child on his parents' farm near Lena, Illinois, not far from the Wisconsin border. As a teenager, he worked summers and weekends at his dad's used farm machinery business. He became interested in a career in journalism and photojournalism, which he learned from Larry Nelson, Hallie Hamilton, Monte Gerlach, and a host of teachers and mentors. As a college student he worked as a reporter and photographer for the *Northwestern Illinois Farmer* newspaper, which was run by John A. "Jack" Dupee Jr., the kind of country editor who could have been played by the actor James Stewart in a movie. Dupee sent him to every kind of assignment, from county fairs to livestock auctions.

Craig earned a journalism degree at Northern Illinois University. He photographed the Lamberty farm while working as a *Wisconsin State Journal* staff photographer. He now works as a photographer in the marketing and media relations office at the University of Wisconsin–Whitewater and teaches photojournalism at Madison Area Technical College. He lives in Middleton, Wisconsin, with his wife, Lisa. They have three sons. He feels that photojournalism will always be the highest expression of his creativity.